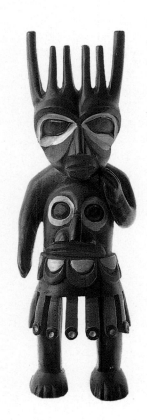

Starfish and sea arch, Olympic National Park, Washington

Coast Salish petroglyphs, Petroglyphs Provincial Park, Nanaimo, British Columbia

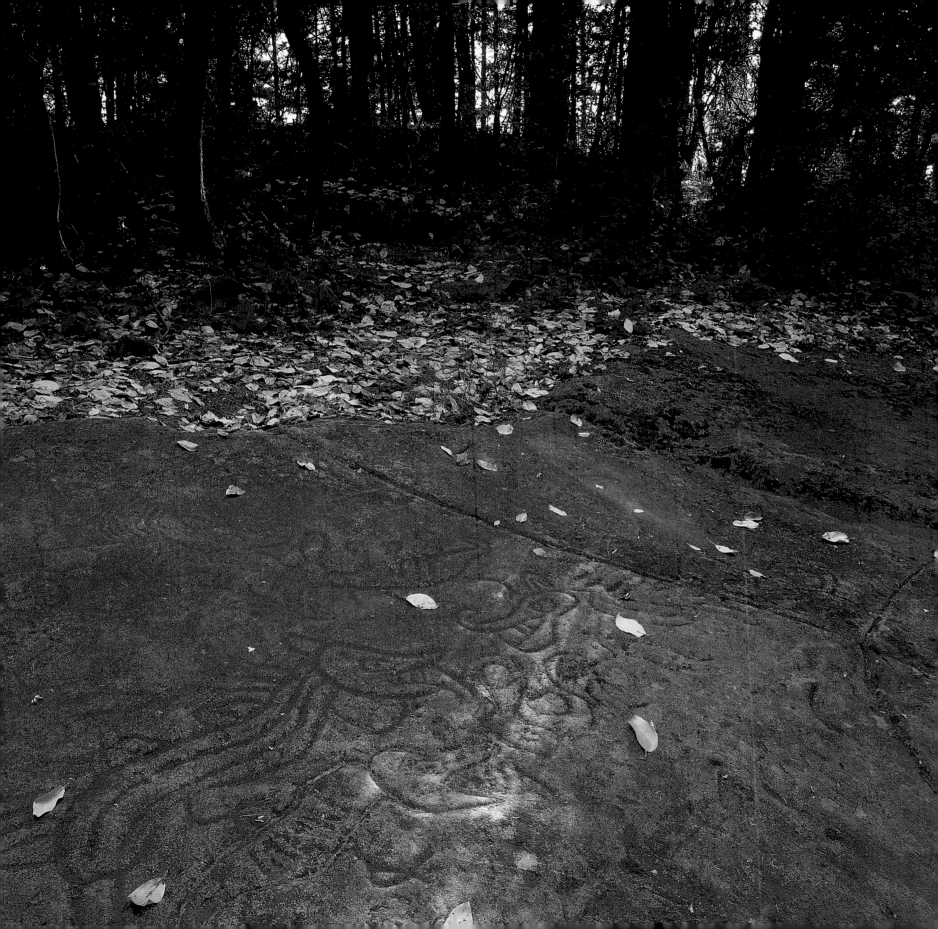

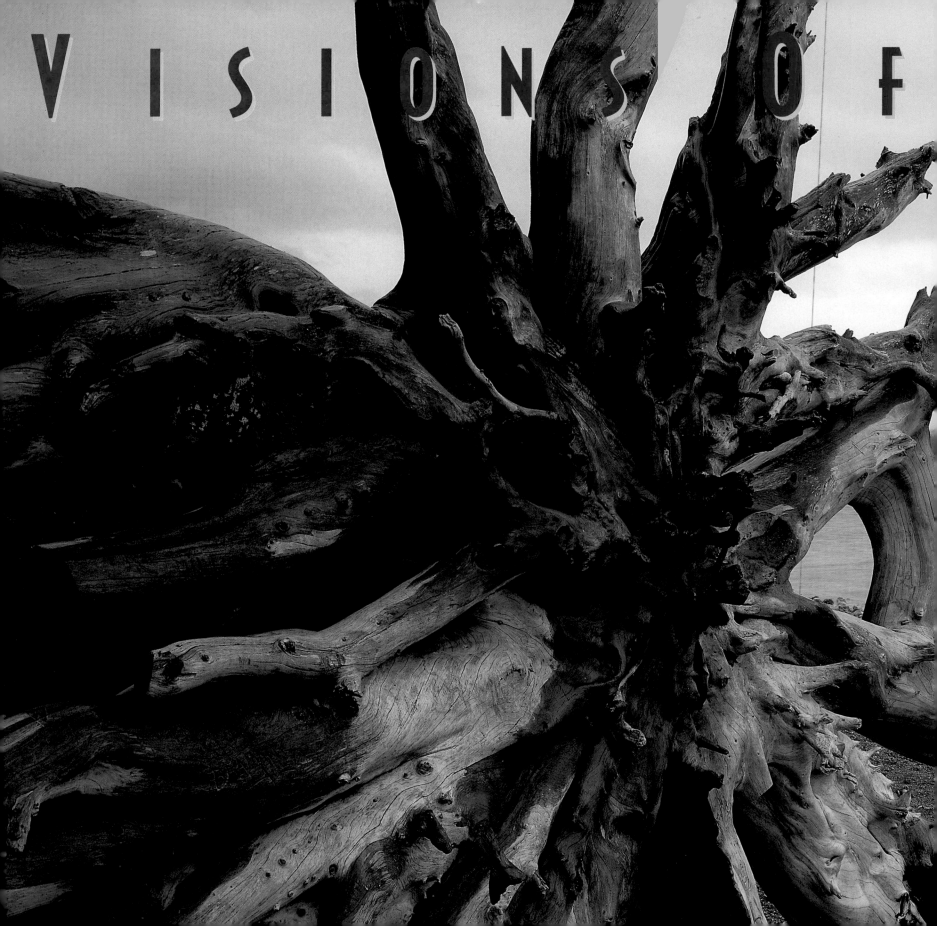

VISIONS OF

THE NORTH

NATIVE ART OF THE

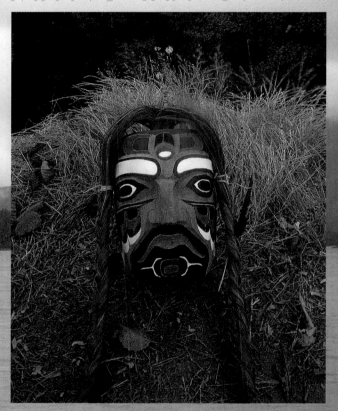

NORTHWEST COAST

BY DON AND DEBRA MCQUISTON
TEXT BY LYNNE BUSH
WITH PHOTOGRAPHY BY TOM TILL

CHRONICLE BOOKS
SAN FRANCISCO

Library of Congress
Cataloging-in-Publication Data available

10 9 8 7 6 5 4 3 2 1

ISBN 0-8118-0881-5 (HC)
ISBN 0-8118-0859-9 (PB)

Distributed in Canada by Raincoast Books
8680 Cambie Street
Vancouver, British Columbia V6P 6M9

Chronicle Books
275 Fifth Street
San Francisco, California 94103

Printed in Hong Kong

Previous page: Site of Auk village, Auke Bay, near
Juneau, Alaska
Inset: Makah mask by Frank Smith

Reflections, Columbia River Gorge, Oregon
Overleaf: Fairweather Range, Glacier Bay National Park, Alaska

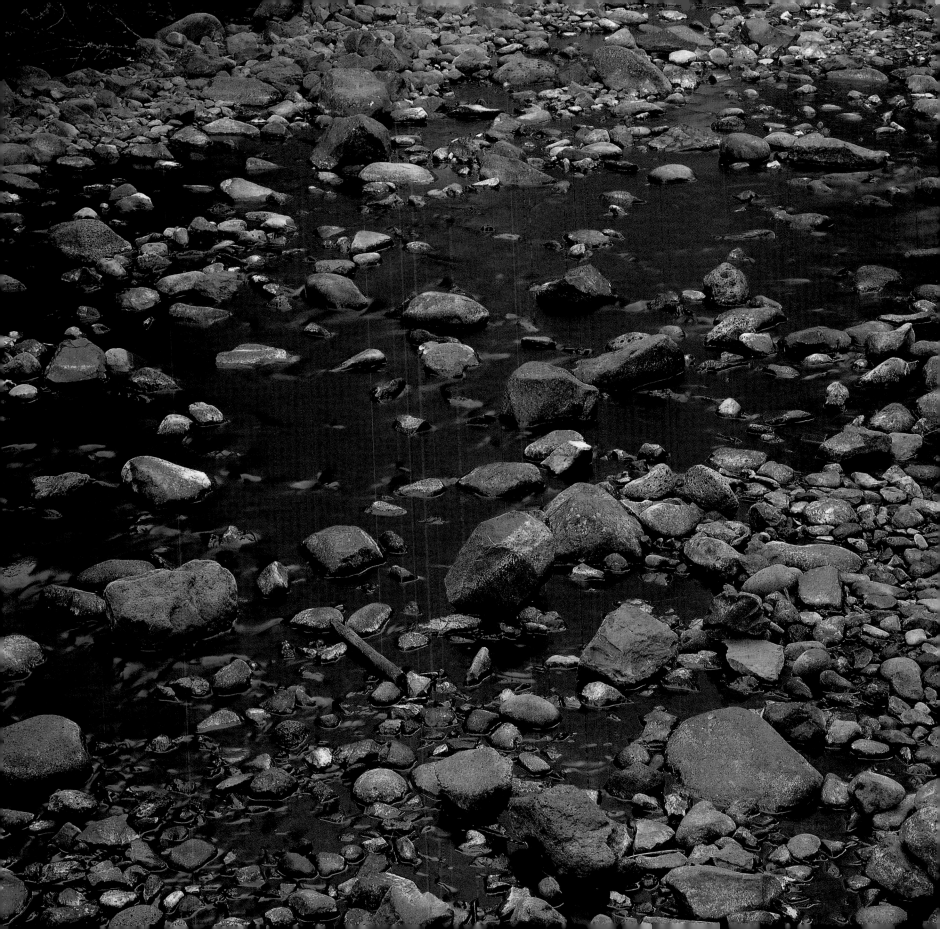

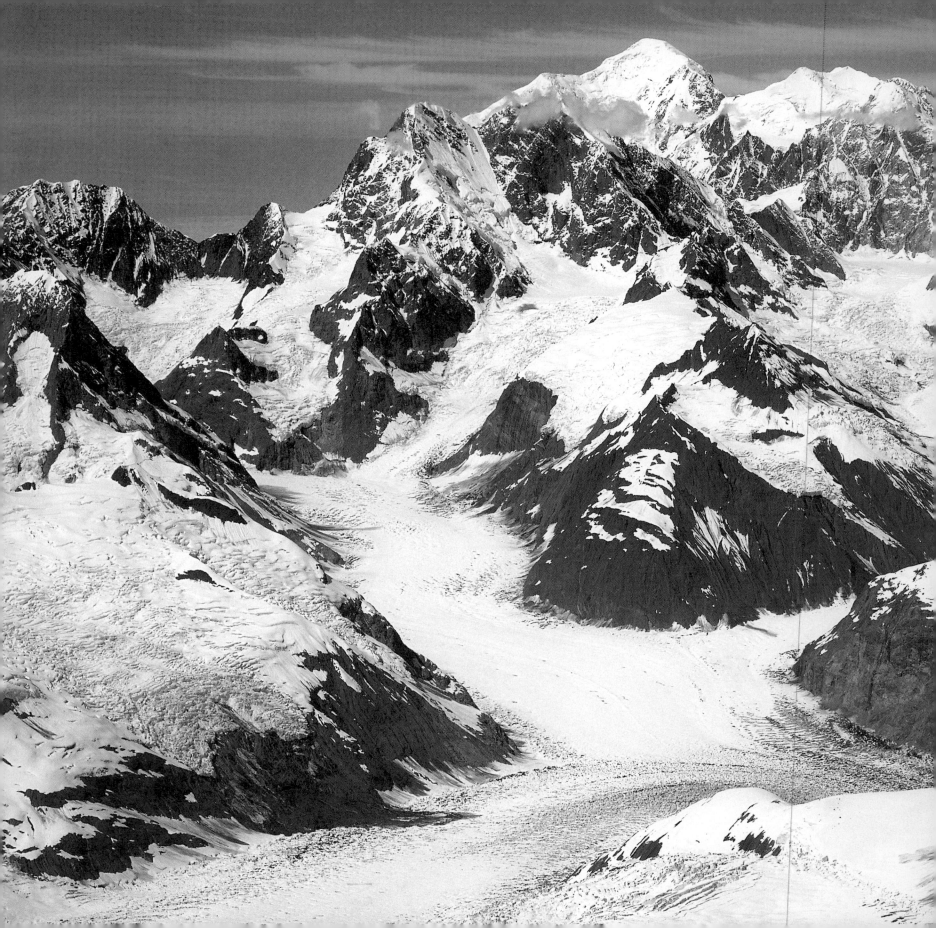

CONTENTS

VISIONS OF THE NORTH

Rose Harbor, South Moresby National Park, British Columbia

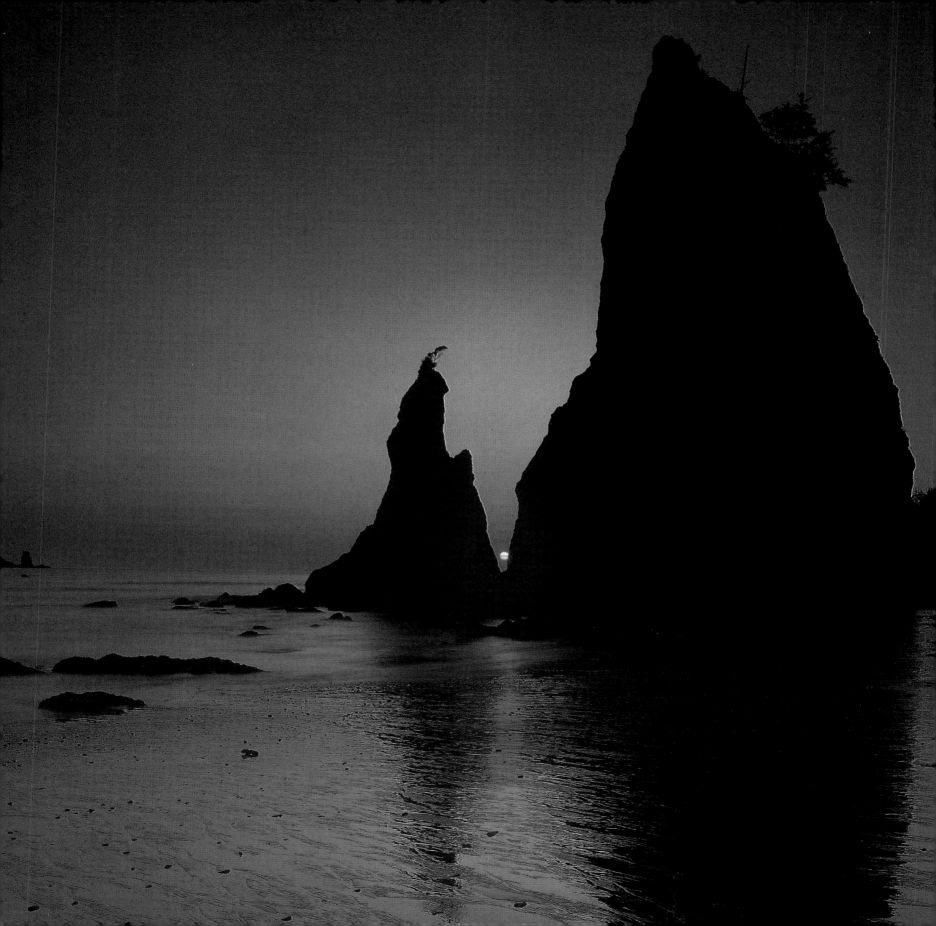

Of Forest And Sea

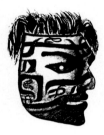

The land of the Northwest Coast Indians is a land of rugged and complicated beauty. Starting slightly south of the present-day border of California and Oregon, it encompasses the western halves of Oregon and Washington, the coast of British Columbia, and the Alaska Panhandle, ending in the north at Prince William Sound. The eastern edge is a complex system of mountains. The Cascades, punctuated by a series of volcanic cones, form the eastern boundary in Washington, Oregon, and California. The Coast Range is the eastern boundary in Canada and Alaska. A multitude of islands, many the tops of submerged mountains, dot the shoreline: the San Juans in Puget Sound; Vancouver Island; the Gulf Islands in the Strait of Georgia; the Queen Charlottes off the northern coast of British Columbia; the islands of the Alexander Archipelago off the coast of southern Alaska; and many other, smaller clusters.

This area is defined not only by its majestic land forms, but also by climate, a climate characterized by high precipitation. The mountains to the east force warm, moisture-saturated Pacific winds to rise. Cooling as they ascend, they drop most of their burden on the mountains' west side. This moisture makes the area home to dense conifer forests, some of them classified as rain forests since they receive up to 220 inches of precipitation each year. Although mild weather is the norm, winter storms can be fierce and unpredictable, with high winds and driving rain.

The mountains that play such a dominant role were formed over millions of years of plates colliding, buckling the earth's crust into complicated folds of mostly metamorphic rock. Pleistocene-age glaciers added finishing touches, scouring and scraping, sculpting *aretes,* jagged vertical ridges, and *cirques,* steep-sided circular basins in which glaciers originate. Thousands of small remnants, sky-blue, fissured pools of ice, still pepper the Northwest Coast's mountains. At Juneau, locals measure the seasons by the Mendenhall Glacier's advance and retreat. At

Seastacks, Rialto Beach, Olympic National Park, Washington

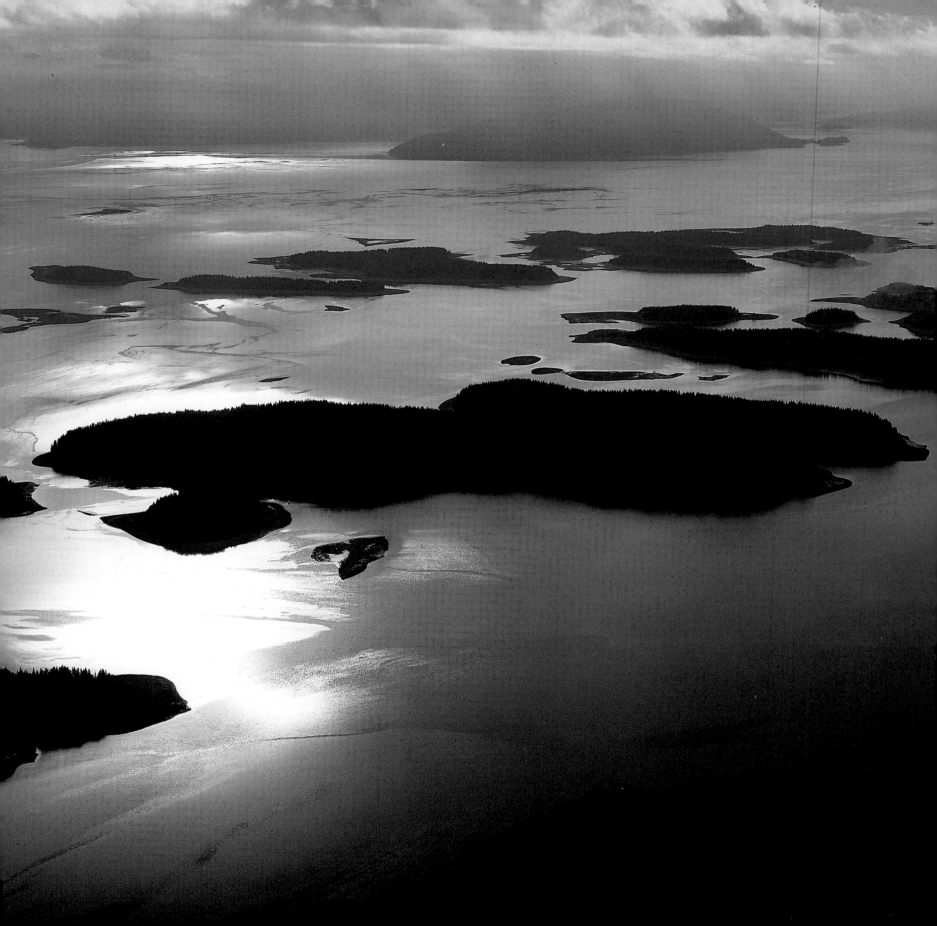

Glacier Bay, the tongues of ice are hundreds of feet thick where they meet the water. Icebergs are born there, calving off into the bay to begin their floating, treacherous journeys.

The Pleistocene ice, sometimes in sheets more than a mile thick, advanced and retreated, advanced and retreated, pulverizing the mountain rock, breaking some of it down to gravel and grinding some to a fine flour—the beginnings of a thin, rocky soil. As the ice sheets melted, removing their ponderous weight from the land, both land and sea began to rise. The sea rose faster, submerging some mountain chains and lapping at the feet of others. Melt waters widened valleys cut by the glaciers, making paths for the mighty river systems of the region—the Stikine, the Nass, the Skeena, the Fraser, and the Columbia.

Plant seeds, either blown in from unglaciated areas or dormant since pre-ice times, began to germinate and take root, further breaking down the soil. The pioneer plants matured and died, contributing organic matter to the soil mix, enabling other species to take hold slowly. Over the centuries, a sprinkling of green appeared where there had been only barren stone.

One of the first trees to colonize was the shore pine, a stunted survivor still found in areas of poor soil and harsh conditions. It gave way to others that grew faster and taller: Sitka spruce along the coast, within reach of the salt spray, and Douglas fir inland. The Douglas fir took up to ten centuries to reach maturity. The seedlings, however, could not survive in the shade cast by the 300-foot tall parents. Shade-tolerant seedlings of western red cedar, hemlock, and others took hold, creating a forest that could

sustain itself relatively unchanged for hundreds of years. As trees were felled by disease or fire, the cycle began again, with Douglas fir giving way to hemlock and cedar. The deeply shaded forest floor was lush with mosses and ferns. Along stream beds, or in clearings where there was more light, alder, maple, and poplar flourished, and salal, Oregon grape, and huckleberries grew in wild tangles.

Into this mythic landscape came humans, walking across the Bering land bridge from Asia into what is now Alaska, into the unglaciated heart of central Canada, then west down the river valleys to the Pacific coast. Their journey took many generations. They walked into what became a land of abundance, where sea and land yielded so much bounty that they needed to work only from spring to fall to collect enough food for the entire year. These ancestors to the present-day tribes developed sophisticated harvesting techniques still practiced by the remaining tribes. The ease of food gathering allowed the more than two dozen groups who lived here leisure in which to develop both a complex social structure based on rank and wealth and an all-pervading artistic sensibility. Although divided by language, their social structure was remarkably similar, leading anthropologists to group them as one culture—the Northwest Coast.

Most of their food was provided by the sea. Five species of salmon—king, or chinook; coho, or silver; sockeye, or red; chum, or dog; and humpbacked, or pink— swam upstream in a boiling frenzy to spawn in their ancestral waters and then die. Up to seven runs per year in the spring and fall provided easily gathered protein. Salmon were netted at stream mouths, caught in traps set behind weirs across deeper streams, or hooked on lines in

Beardslee Islands, Glacier Bay National Park, Alaska

offshore waters. Eulachon, or candlefish—oily silver min-
nows whose bodies yielded grease for food and light—
were netted as the salmon were. Halibut were caught on
U-shaped, spruce-branch hooks baited with octopus, then
dispatched with a special halibut-killing club as they were
brought up alongside the canoe. Herring were raked out of
the sea. Clams, crabs, mussels, and other shellfish; fish
eggs; octopus; and edible seaweed were gathered and pre-
served. Fish were cleaned and dried at fishing camps, then
transported back to be hung in the long house rafters,
glinting in the firelight like gold in a communal treasure
chest. Seals and sea lions were hunted for food and fur,
otter for their silky pelts. Nootka and Makah men hunted
whales, going to sea in 70-foot canoes equipped with
seemingly flimsy harpoons, 18 feet long and tipped only
with a sharpened mussel-shell point.

The land also yielded riches. Many types of edible
berries, including salmonberries, huckleberries, blackber-
ries, and salal, were gathered and preserved. Gull eggs
were collected. Roots and tender bark were steamed and
stored; skunk cabbage provided fresh greens. Deer and elk
were hunted with bows and arrows. Bears were trapped or
treed, then shot with arrows. Mink, ermine, raccoon, and
martin were trapped for their pelts. Some northern tribes
hunted mountain goats for their wool and horns.

The greatest resources of the land by far were the
trees. Most of the people's material goods were made of
wood or bark: hair combs, fish hooks, barbed spear points,
grease bowls, large ladles and other utensils, seal clubs,
fishing spears, canoes and paddles (vital since the rugged
terrain and dense forests made travel over land impracti-
cal), bows and arrows, the wedges used to split logs, mats

and baskets, totem poles, frontlets and masks, and houses.
Yew, alder, red and yellow cedar, hemlock, and spruce
were each put to a specific purpose. The huge planks used
to side the long houses were adzed from still-standing
trees. Inside the house, huddled around communal fires,
women prepared food in wooden cooking boxes, heating
liquid in them by dropping in hot rocks. These bentwood
boxes, also used for storage, were made from a single slab
of wood, kerfed on one side, then bent while being
steamed. The fourth corner and bottom were pegged into
place or sewn shut with bark thread. The inner bark of
cedar provided stringy fibers from which twine could be
made. Baskets were twined of spruce root. Clothing was
woven of cedar bark strips, pounded to softness and some-
times enhanced with bird down or dog hair. Cedar bark
also adorned many of the ceremonial masks, hanging
down like hair to conceal the wearer's face.

The abundance of food and ease of gathering it
allowed the people to establish permanent villages, though
they might spend the peak fishing season at a camp near the
river to which they held rights. The clan or long houses sat
right above the high tide mark, parallel to the shore.
Fantastically carved and painted totem poles, on which
mythic animals represented the crests of the owner's
family, stood at the front of many of the houses. In some
villages the house doors were elaborately carved poles,
and often the entrance was the gaping mouth of a stylized
animal. Frequently the house front was also painted with
crests. The weathered structures, on the fringe between
forest and sea, were not just shelter. They were the center
of a rich ceremonial life, carried out during the leisure of
the winter months.

Overleaf: Eagle Creek, Mount Hood National Forest, Oregon

ALASKA

Anchorage

Homer

COOK INLET

GULF OF ALASKA

YUKON

NORTHWEST
TERRITORIES

Whitehorse

CAPE SPENCER

Haines

Juneau

BRITISH

PACIFIC OCEAN

Sitka

Wrangell

COLUMBIA

Ketchikan

DIXON ENTRANCE

ALBERTA

Prince
Rupert

Queen
Charlotte
Islands

Bella
Bella

Bella Coola

THE
NORTHWEST
COAST
*from Northern California
to the Gulf of Alaska*

Vancouver Island

Vancouver

JUAN DE FUCA STRAIT

Victoria

Bellingham

Seattle

WASHINGTON

COLUMBIA RIVER

Portland

OREGON

CALIFORNIA

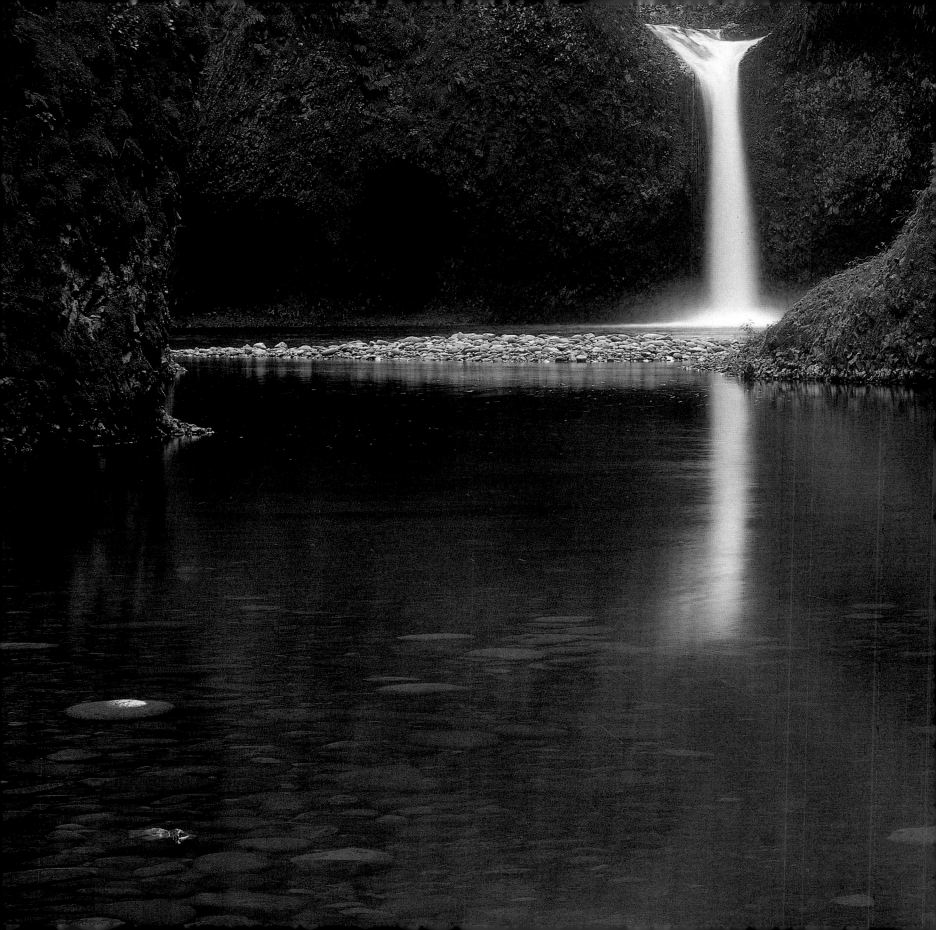

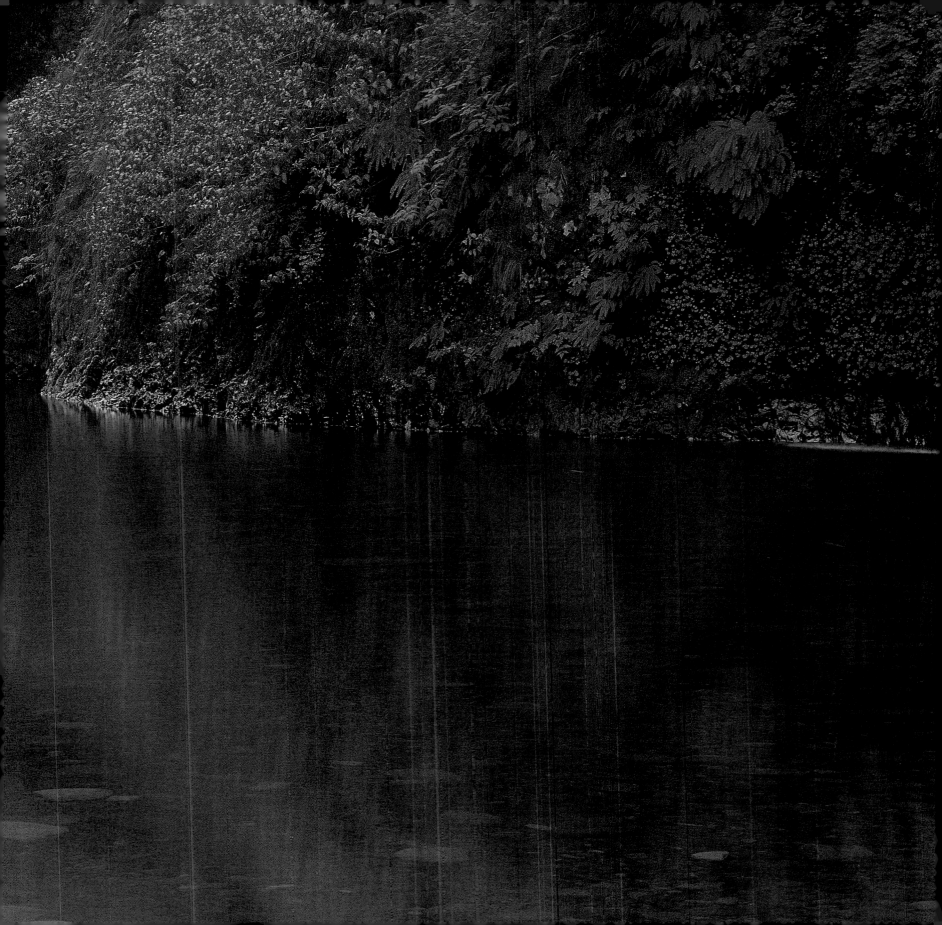

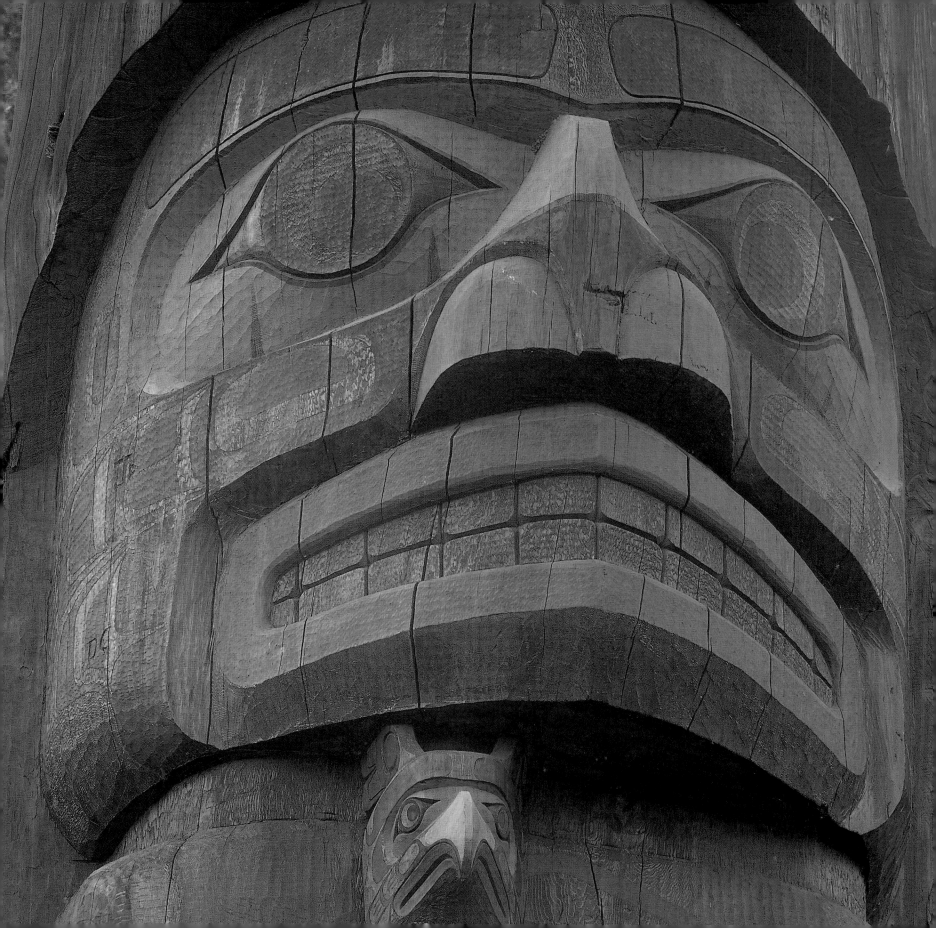

A VISION OF ART

In the short days of winter, gathered around a fire in the long house, elders would tell stories. Family members sat listening, fingers busy, perhaps twining a basket or carving a horn spoon. Some evenings everyone in the village might gather to witness the taming of an initiate of one of the dance societies, or to gorge on delicacies reserved for potlatch feasting.

The slow pace of winter allowed time for feasts, merriment, and relaxation. Women repaired household goods; made baskets; wove clothing of cedar bark; and carefully adorned dance blankets of trade cloth with bits of abalone shell and pearl buttons. Men built canoes and carved and painted utilitarian objects, mostly of wood, but also of horn and bone. Carved silver jewelry became common after contact with Europeans, as did Haida carvings of argillite, a soft, black slate.

All functional items were decorated by their maker, generally covered on all surfaces with the swelling, sinuous formline style characteristic of Northwest Coast art.

Tlingit women and men collaborated on the highly prized Chilkat blankets—men providing the pattern boards and women executing the weaving. In other tribes, basketry hats were woven by women and painted by men. Craftsmen were apprenticed to masters to learn to carve the great commemorative poles that incorporated family crests, and to paint and carve masks, rattles, frontlets, and other ceremonial objects.

Although some tribe members received special training in specific crafts, everyone was an artist. Each individual created art, whether by embellishing a ladle handle, by carving a house post, or by performing the complex movements of a dance. Art and life were not separate categories. One was entwined with the other, creating a world rich in symbolism and visual beauty.

The symbolic vocabulary of Northwest Coast art is highly structured, governed by a set of conventions that seem too rigid to allow originality. Looking at examples, however, of both two-dimensional surface decoration and

Detail of world's largest totem pole, carved by Richard Hunt in Kwakiutl style, Duncan, British Columbia

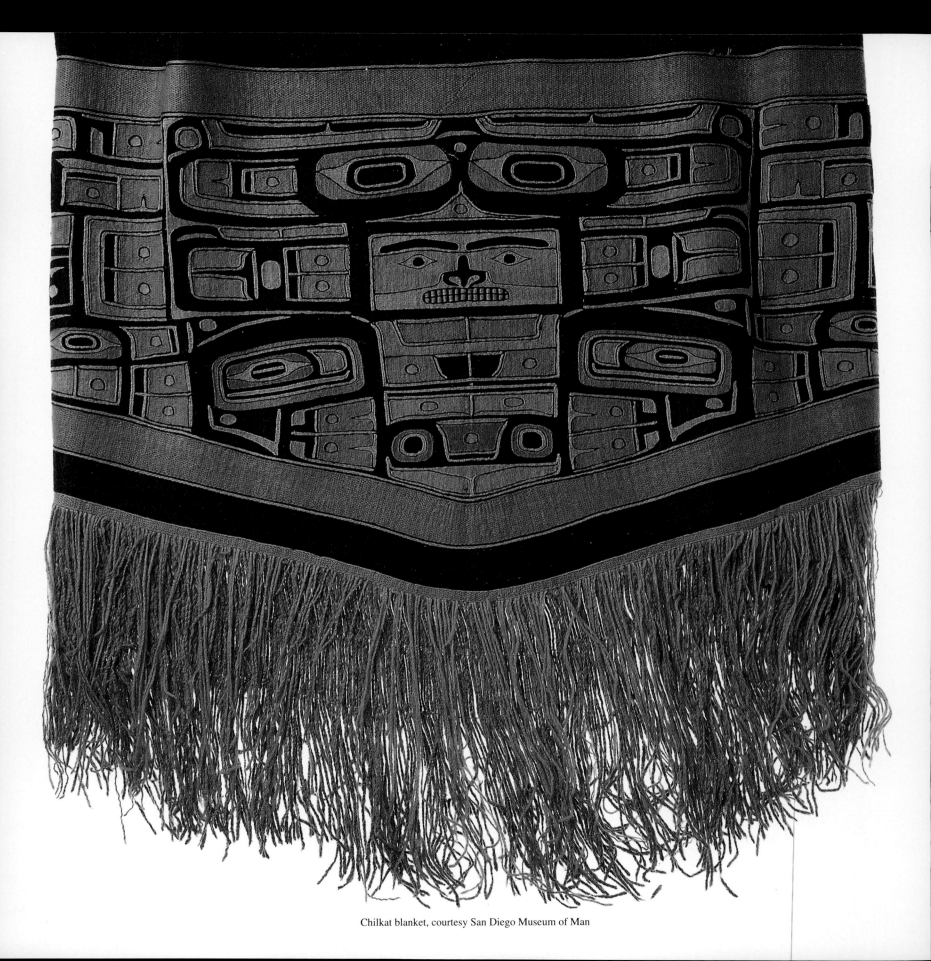

Chilkat blanket, courtesy San Diego Museum of Man

sculptural carvings, the wide range of expression available within the rules is clear.

Most Northwest Coast art is representational; that is, it is a picture of something, most often an animal. Use of certain creatures is traditionally restricted to those who hold rights to them through clan or family ties. For instance, Raven clan members could display the Raven crest, but through marriage or a spirit encounter, individuals might also own Frog or Dragonfly or a unique version of Raven.

The art is generally symmetrical around a vertical axis. Three colors are used repeatedly, with some slight variation: black, the primary color, is used for the formline; red is used for details and for secondary formlines; and blue or blue-green is used for less important elements. The artist uses repeated shapes—mainly ovoids and U forms—to show the whole animal, often in a split-body view. The black primary formline, which is continuous, defines the most important features. Body parts are often rearranged and turned back on themselves to fill every inch of the allotted space, increasing the degree of abstraction to the point that the animal represented is unrecognizable. This is usually the case with Chilkat blanket designs. Elaborated ovoids, often read as extra faces or eyes, actually define the major joints of the animal's body. The rhythm of repeated elements, the swelling and thinning of the formline, and the use of color create a movement and liveliness that draws the eye in and around. These artists are also masters of visual punning, wherein the head of one animal may become the tail of another at second glance.

The basic elements were applied on all scales, from tiny engravings on silver jewelry, beaten from coins, to dance blankets and aprons of hide and trade cloth, to gigantic paintings on house fronts. Although similar conventions of two-dimensional design were followed along the coast, northern artists tended to apply them more rigidly. Naturalistic representations and looser interpretations were more common to the south. Masks and three-dimensional sculpture also vary from north to south.

This sophisticated style stands with the best of world art from any era. Deciphering the riddle of a complex design is deeply satisfying, generating a sense of wonder and a connection to its creator. But why did these people place so much emphasis on creating beautiful objects? Part of the answer lies in their intricate social structure, in which gifts were given both to pay for services rendered and to validate the worth of the giver and the receiver.

The highly structured Northwest Coast societies were based on a wealth made possible by stored surpluses. Wealth and status were measured not only in material rights, such as the right to certain fishing streams or berry patches, but also in the right to use and display clan crests, to claim hereditary titles, and to participate in certain ceremonies and performances. Noble families held the most rights, but even commoners held some rights. Slaves, captured or purchased from other tribes, were considered part of their owner's property. They were buried under the massive corner posts of a long house as it was built or, often, sacrificed as a demonstration of their owner's wealth.

Individual rights were and still are validated through the complicated practice of potlatching, carried out in one form or another by almost all of the tribes of the Northwest Coast. A potlatch, a several-day series of events, was thrown for one or more of several purposes: to

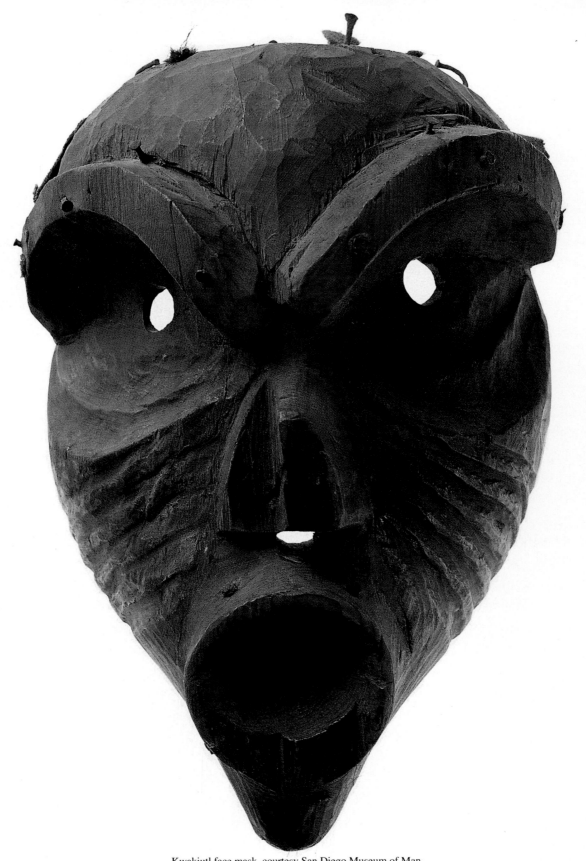

Kwakiutl face mask, courtesy San Diego Museum of Man

mark an important life event, such as the building of a long house; to enhance personal prestige and display wealth; to save face after an embarrassment; or sometimes to shame or best a rival, in a mutual destruction of goods.

In the autobiography of James Sewid, a Kwakiutl chief, Sewid recounts a family story of a potlatch held for him when he was ten months old. At that time he received many titles, both from his mother's and father's families: "He Is Wealthy from Many Generations Back," "A Very High-Ranking Man," "Always Giving Away Wealth," "He Always Wants to Share His Wealth with Others." Though he was not yet out of diapers, James was already considered an important personage in Kwakiutl society.

Potlatches were also given in payment for services. Most of the tribes were divided into two hereditary groups, each associated with an animal. Haida, Tlingit and Tshimshian, for example, were divided into Ravens and Wolves or Eagles. Typically a long house was built by members of the hereditary group opposite the owner's. He then had to pay them with gifts and feasting. Artisans who had been engaged to carve the house posts and create other clan-related art for the new house would also be paid with gifts.

Another common occasion for a potlatch was the raising of a memorial pole in honor of a deceased chief. First the sponsor, usually the head of the clan, and his family decided when to hold the potlatch and sent emissaries to the guests' village to extend an invitation. Then they prepared, sometimes for several years, amassing food and gifts. In the early days coppers—giant, shieldlike plates hammered out of copper—and slaves were the currency of the potlatch; in modern times wool blankets, silver jewelry, appliances, and cash are common potlatch

goods. All members of the clan pitched in, since their status was enhanced by the increased status of any group member. Material goods were borrowed and credited against the loaner's future, similar needs.

When the guests arrived, they greeted their host with speeches extolling his virtues; the host then invited each guest to a seat of honor in the long house. Several days of feasting, dancing, and contests followed. The culminating event was the presentation of goods, with each visitor receiving a gift in accordance with rank.

Such a ceremony not only honored the deceased, but also indicated the sponsor's assumption of the rights and privileges of the deceased. Acceptance of the gifts was an acknowledgment of the giver's rights: in some ways, the guests were paid witnesses. A large and extravagant potlatch not only added greatly to the clan's prestige; it ensured that tales about it would be passed down, further reinforcing the sponsor's rights.

In the early twentieth century, potlatching was outlawed by both Canada and the United States in an effort to force the native peoples to assimilate. Some created new traditions: The Makah converted the contests and feasts of the potlatch into the sack races and picnics of the Fourth of July. Others carried on: Kwakiutl elders were jailed. More frequently, the people balanced uneasily between the two worlds. Songs and dances died with their owners, and ceremonial objects, collected by anthropologists eager to record the workings of "primitive cultures" before they expired, gathered dust in museum cases. The last thirty years, however, have been a time of renewal, as young native artists seek the roots of their art in the old ways. The elders have been consulted, their knowledge preserved. And Raven brings light to the Northwest again.

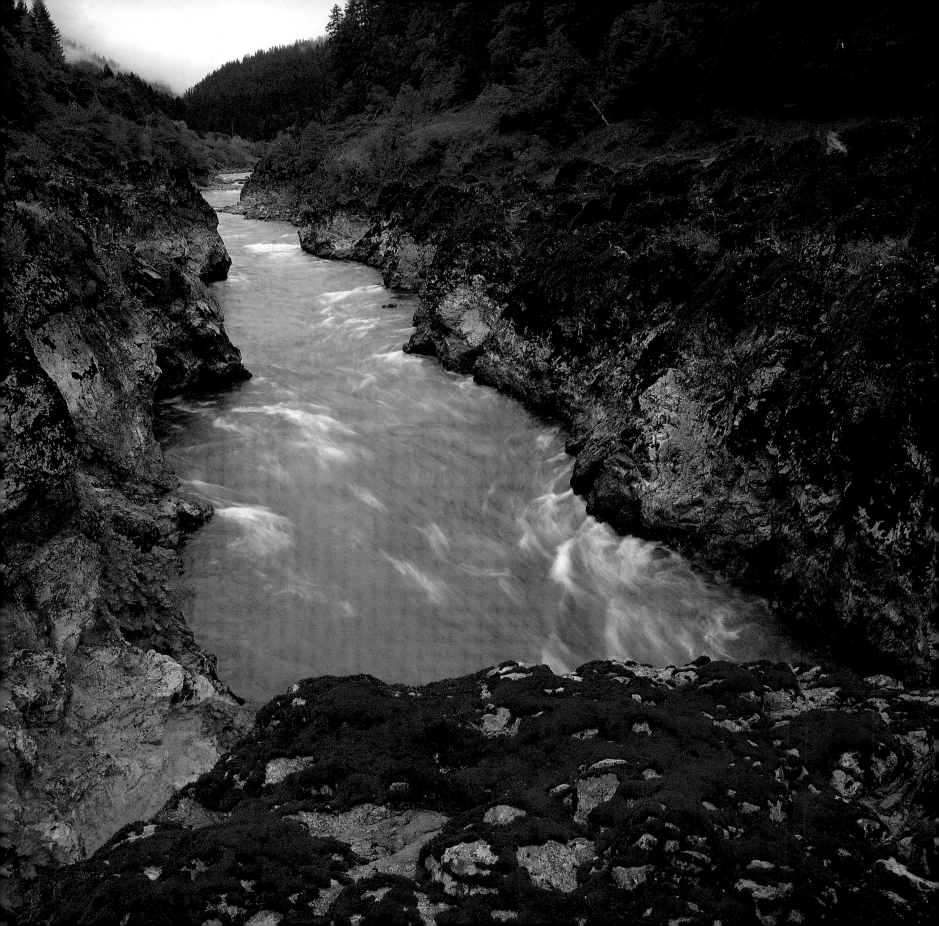

THE SOUTHERN COAST

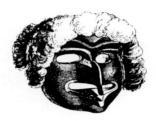

A damp day in the middle of fall. Everything, even sound, is damp and muffled. Fog hangs below the tree tops in a small clearing, mixing with the smoke from the chimney of a cozy-looking house. There are many such clearings, each with a house or small farm, bounded on one side by the road, closed in on the other three sides by trees. The trees are a dense evergreen wall perched at the edge of the clearing, as if they are waiting for a chance to reclaim it.

Once many tribes inhabited these forests and shores. The Salish, the Lummi, the Quileute, and the Nootka, among others, still make their homes here. The Makah, living as they do at the tip of the Olympic Peninsula in Washington, face water to the west and north, trees to the south and east. A winding two-lane highway connects them to Port Angeles, to the ferries across the Sound, to Seattle, and to the outside world.

For much of the ride to Neah Bay, the reservation's main town, the water is in sight, heavy and gray. Canada is a green-black stripe of land on the near horizon, across the Strait of Juan de Fuca. Three bald eagles swoop and curl over the waves. There is no beach, only rocks, or a thin strip of sand barely the width of the difference between high and low tide. If the road were not here, the trees would extend to the water's edge.

By the time the Makah Cultural and Research Center is in sight, the air has begun to release moisture as rain. On display inside are some of the 15,000 artifacts recovered from an 11-year dig at a site on the Pacific, roughly 15 miles south of here. Around 500 years ago a mud slide covered several long houses at the year-round village of Ozette. What the mud has yielded up has helped keep present-day Makah in touch with their heritage.

There is much local involvement in the Center's museum and programs. Two canoes, built by tribe members, fill most of the first display hall. Farther inside is a replica of a traditional Makah long house, with straight sides of overlapping cedar planks. A heady, smoky odor

Mule Creek Canyon, Rogue River Wilderness, Oregon

wafts from racks of smoked salmon and halibut drying in its rafters, and soft, musical chanting fills the air. A nearby sign identifies the sounds as a recording of the Makah language, made by tribal elders. Other carefully lettered signs explain the mysteries of the many artifacts. Photographs of local leaders, past and present, hang in the hall by the exit.

The present-day center of community life, the general store, is in the middle of town. Inside, above a counter in the corner, are masks carved and painted by local artists. Several of them have pursed lips and fearsome faces. They depict Dsonoqua, or Sasquatch, the legendary whistling cannibal giant who may still live in the woods near town. Beyond the store, within feet of the highway, are the docks. Although they no longer hunt whales from canoes, most Makah are self-sufficient, still earning their living from the sea. The riches of their environment and of their past make them wealthy still.

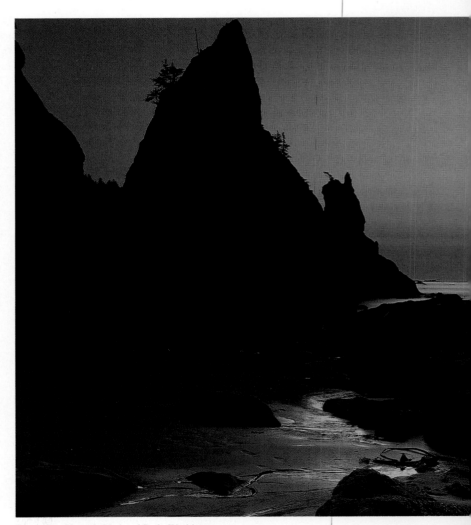

Seastacks, Olympic National Park, Washington

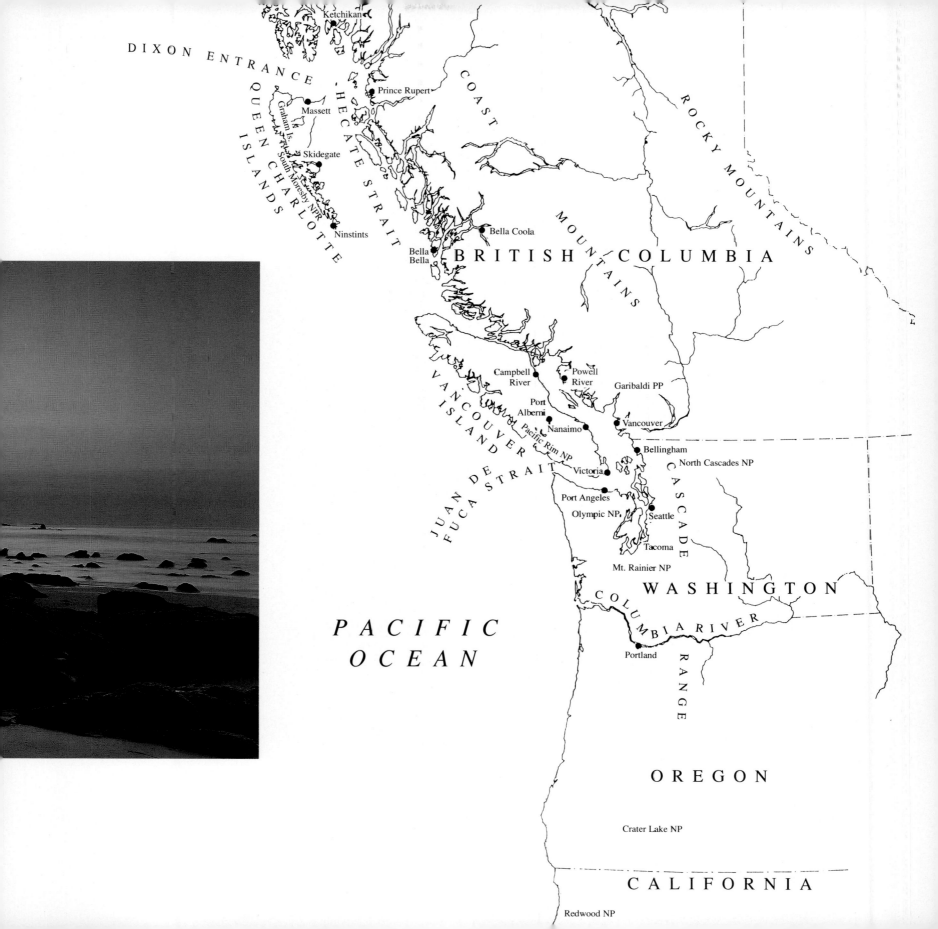

DIXON ENTRANCE

Ketchikan

Prince Rupert

QUEEN CHARLOTTE ISLANDS

HECATE STRAIT

COAST

ROCKY MOUNTAINS

Massett

Graham Is.

Skidegate

South Moresby NPR

Ninstints

Bella Coola

Bella Bella

BRITISH COLUMBIA

MOUNTAINS

Campbell River

Powell River

Garibaldi PP

VANCOUVER ISLAND

Port Alberni

Pacific Rim NP

Nanaimo

Vancouver

Bellingham

North Cascades NP

Victoria

JUAN DE FUCA STRAIT

Port Angeles

Olympic NP

Seattle

CASCADE

Tacoma

Mt. Rainier NP

WASHINGTON

PACIFIC OCEAN

COLUMBIA RIVER

Portland

RANGE

OREGON

Crater Lake NP

CALIFORNIA

Redwood NP

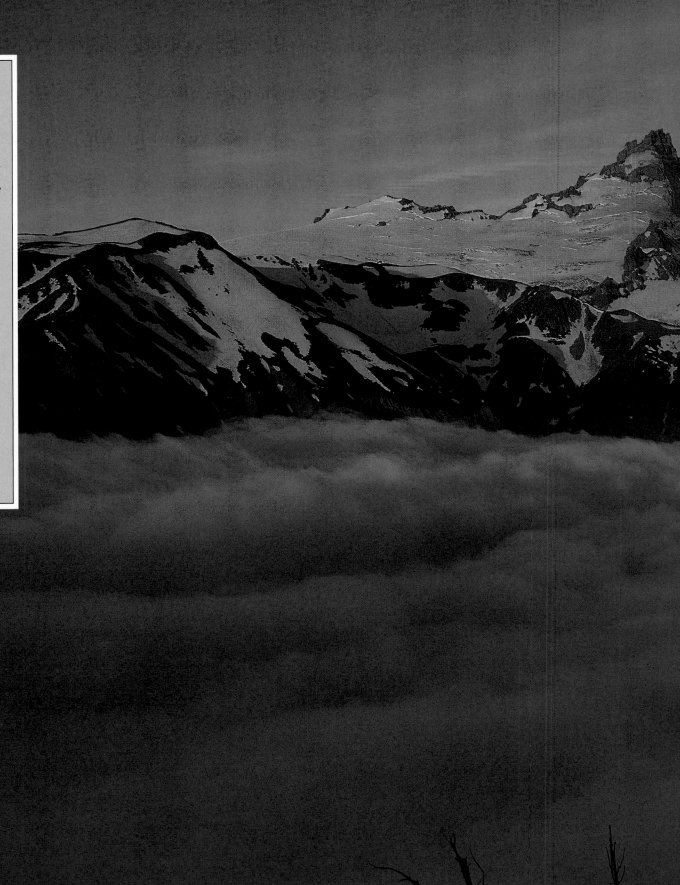

*T*he mountains that serve as backdrop to the Northwest Coast's beauty are part of the Ring of Fire that rims the Pacific Ocean. The ranges are punctuated by a series of active volcanic cones, such as Washington's Mount Rainer, a glacier-clad giant rising 14,411 feet from the coastal plane to the east of Puget Sound. Like its neighbor to the south, Mount Saint Helens, it will more than likely come to life again, reminding us of nature's devastating power.

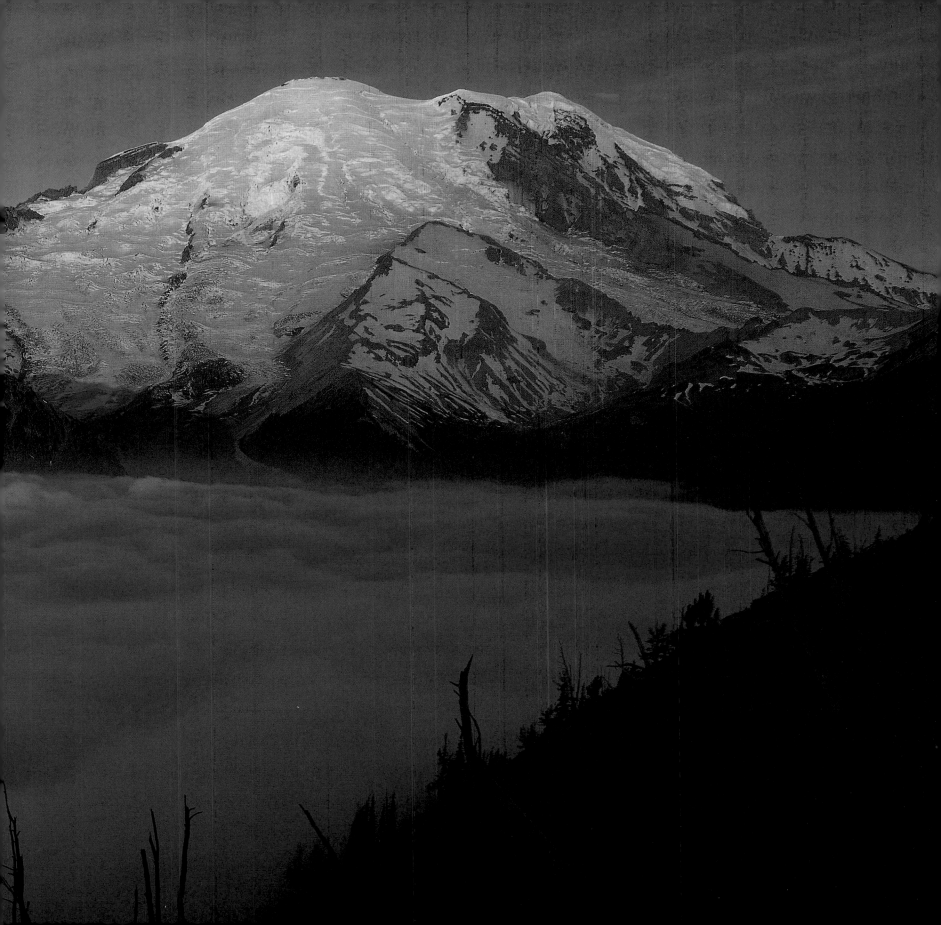

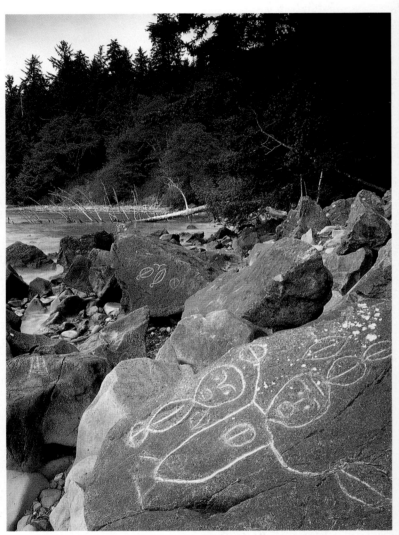

Petroglyphs, Yellow Island, Gulf Islands, British Columbia

Makah petroglyphs at Wedding Rock, Olympic National Park, Washington

It is difficult to say for certain how long these figures, cut into the rock, have endured. It is thought that people reached the coast by 8000 B.C., some 2,000 years after the last ice sheet retreated. By the time Europeans first visited the area in the late 1700s, the Northwest Coast culture was in full flower.

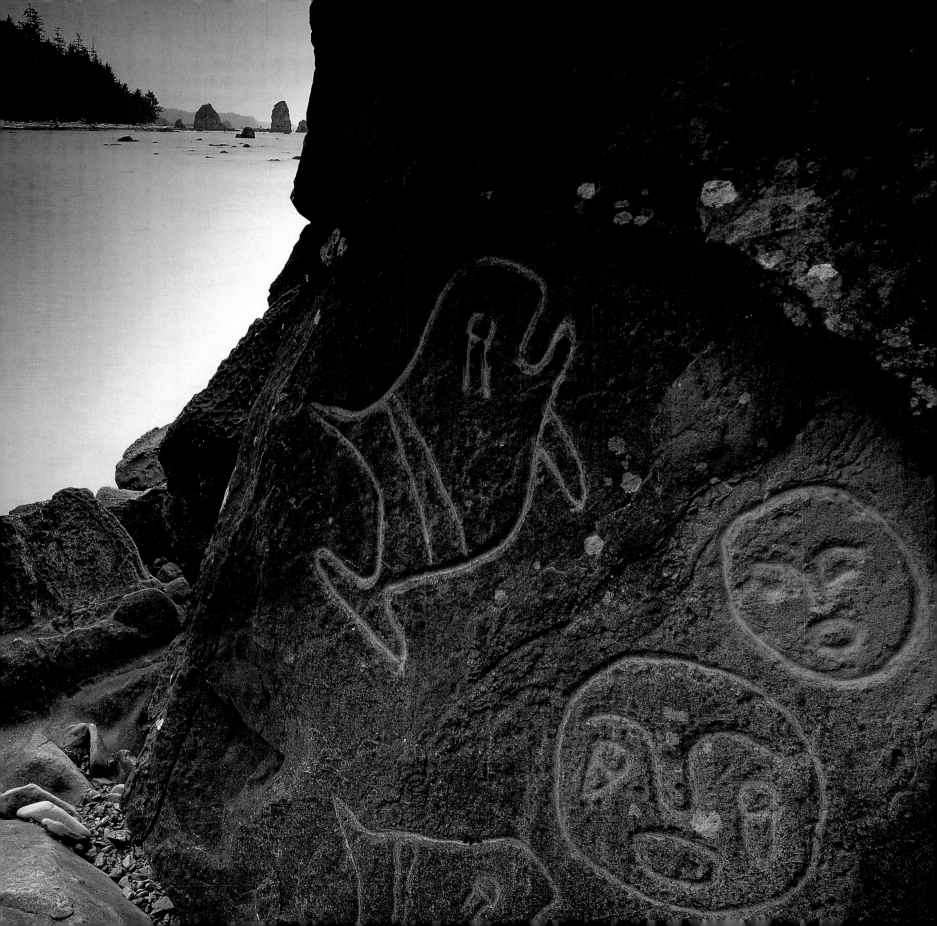

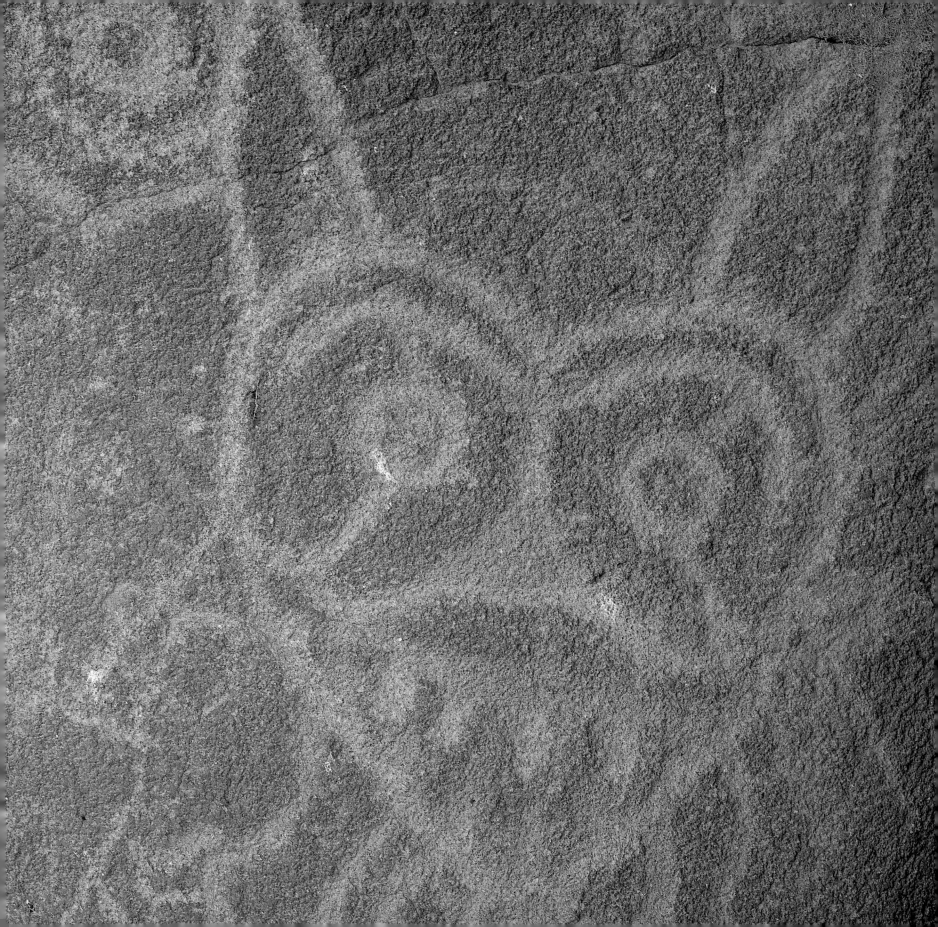

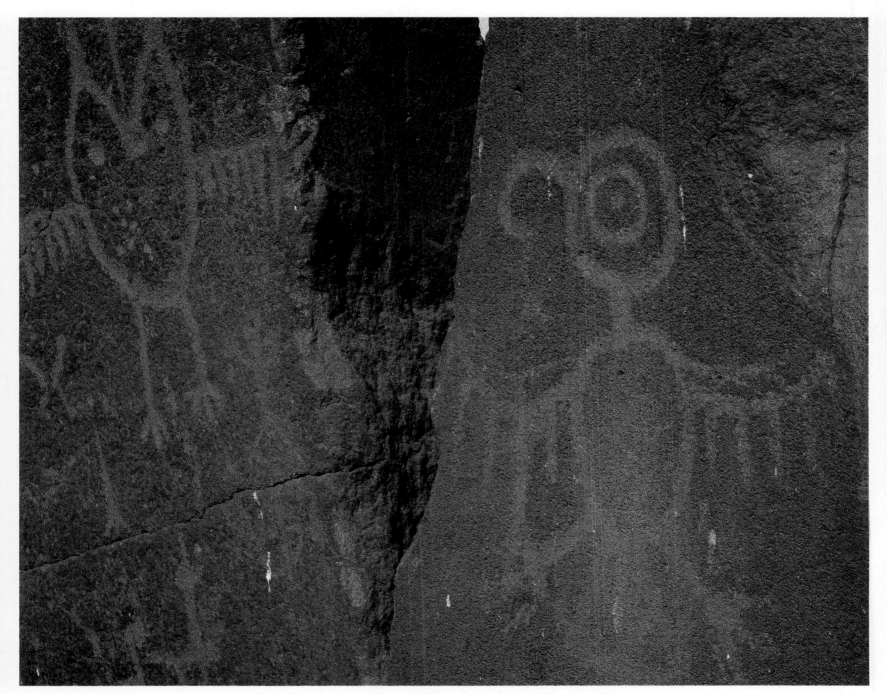

Owl and Thunderbird petroglyphs, Petroglyph Canyon, Columbia River Gorge, Oregon

Monster Petroglyph, Columbia River Gorge, Oregon

36

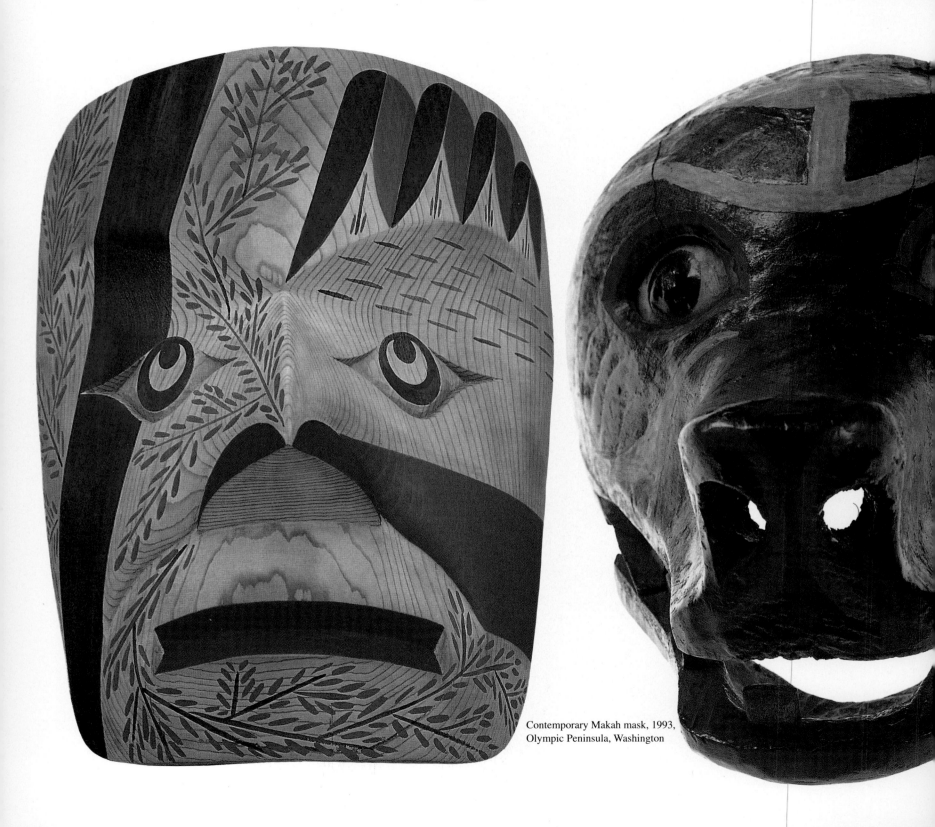

Contemporary Makah mask, 1993,
Olympic Peninsula, Washington

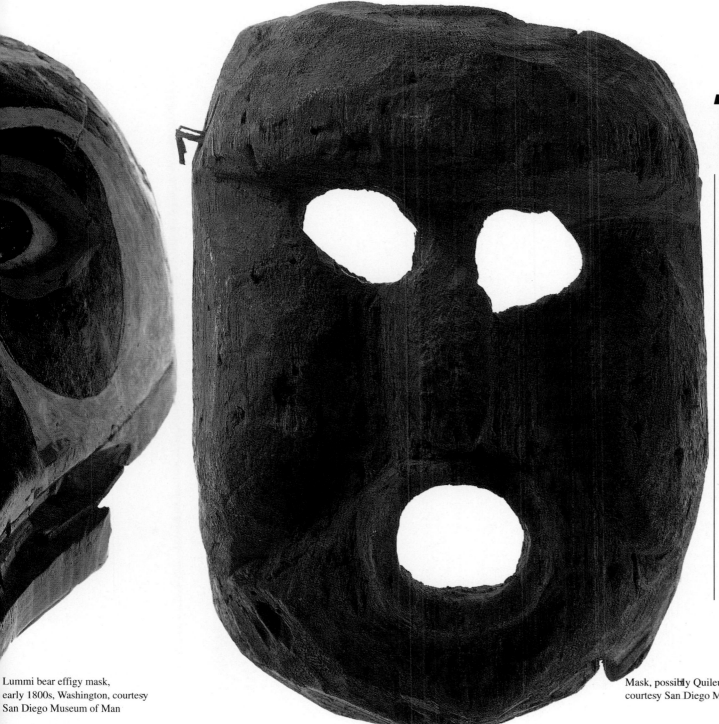

The people symbolized their kinship with the animals by adopting the aspects and names of the creatures as family crests. Boundaries between the animal and human world remained fluid, and transformations were reenacted with the aid of elaborate masks, which could easily flap open at a crucial moment in a dance to reveal the human inside a bird or beast. Masks displaying crests and bringing to life mythological creatures like Dsonoqua, the whistling cannibal giant, played a large part in the illusions created during the winter ceremonials.

Lummi bear effigy mask,
early 1800s, Washington, courtesy
San Diego Museum of Man

Mask, possibly Quileute, Washington,
courtesy San Diego Museum of Man

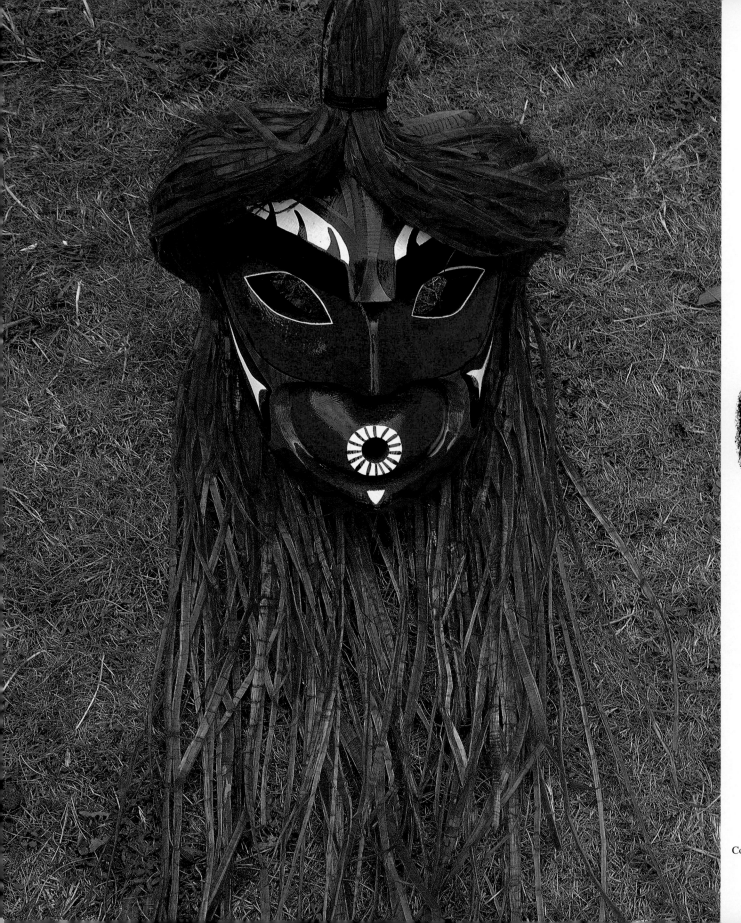

Contemporary Makah masks, Washington

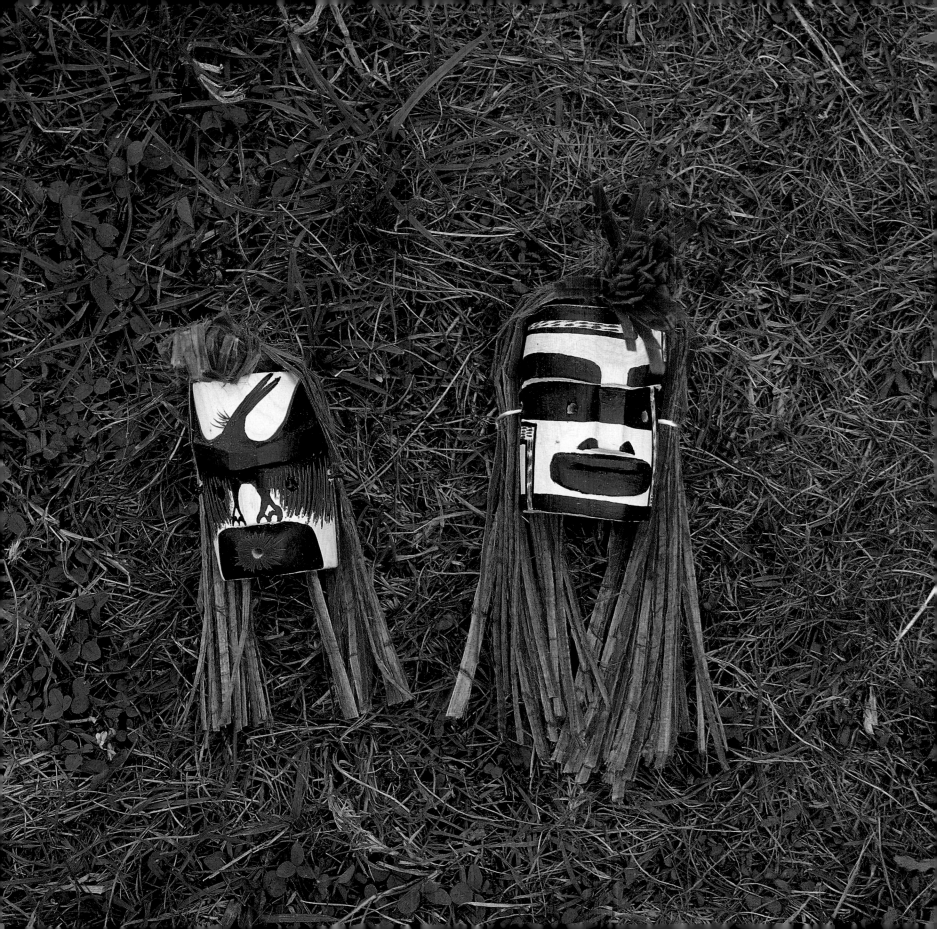

40

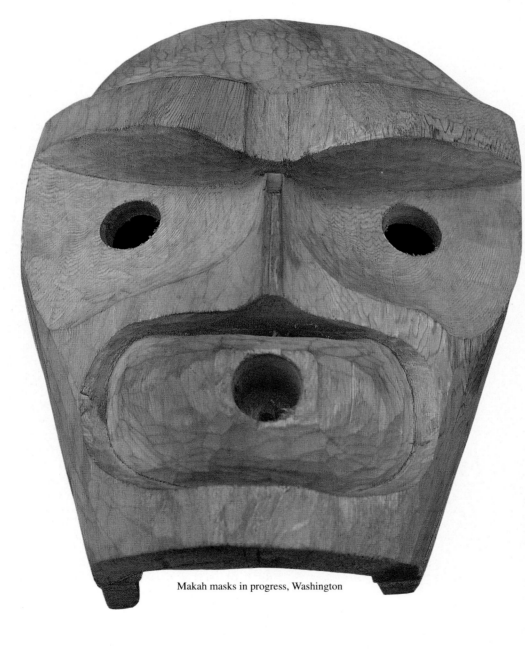

Makah masks in progress, Washington

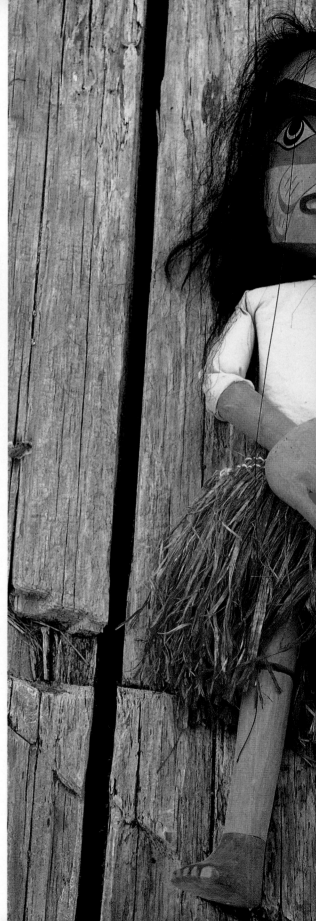

Kwati Trickster, Makah puppet the size of a 10-year-old child, speaks with a lisp, Washington

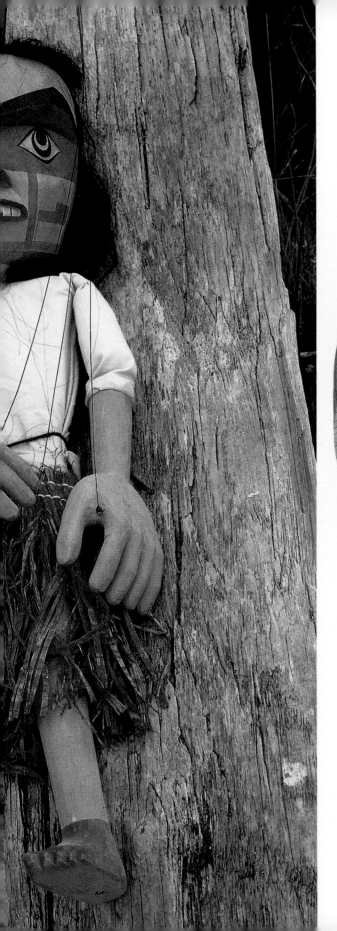

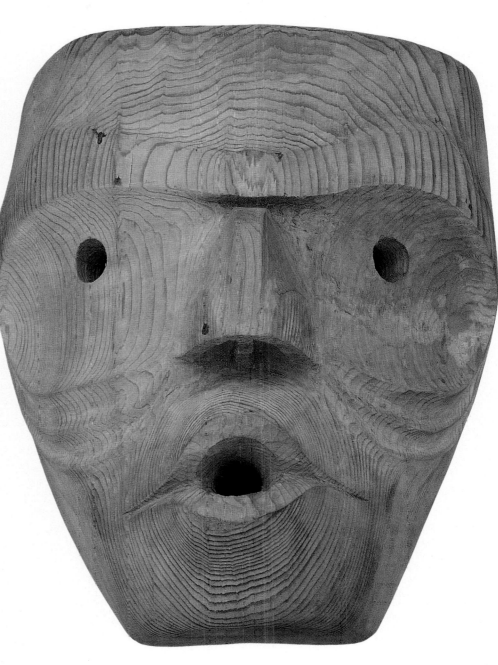

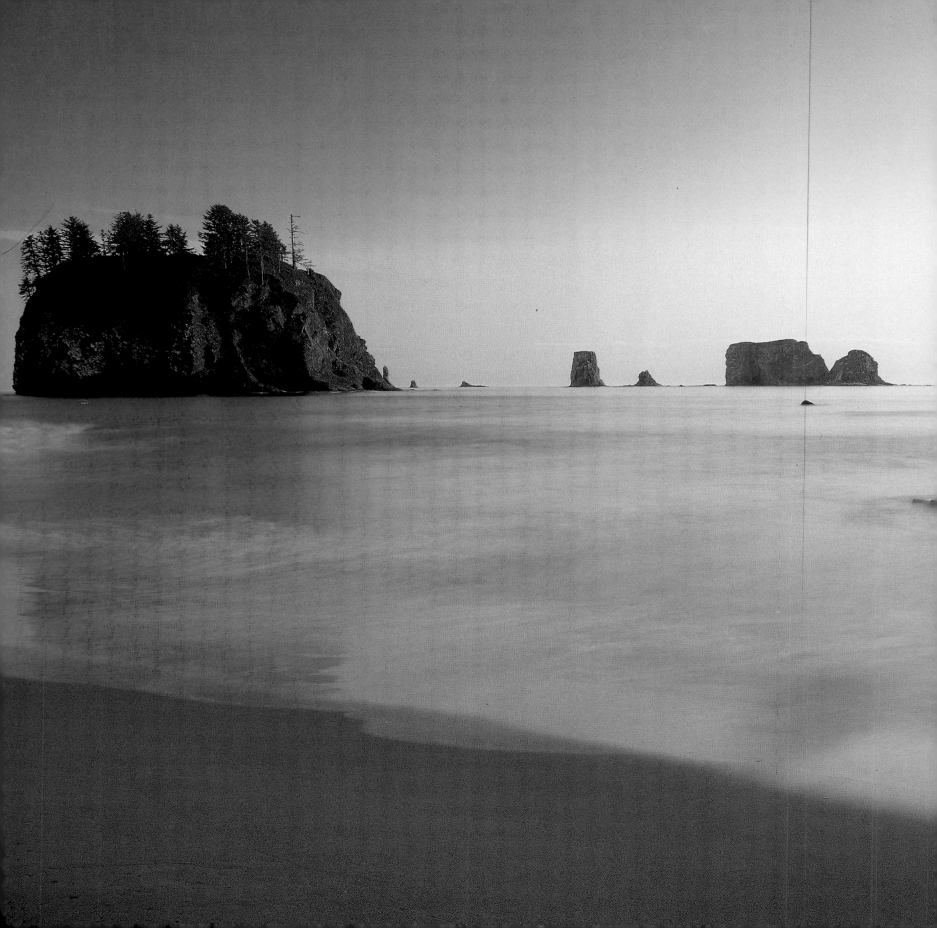

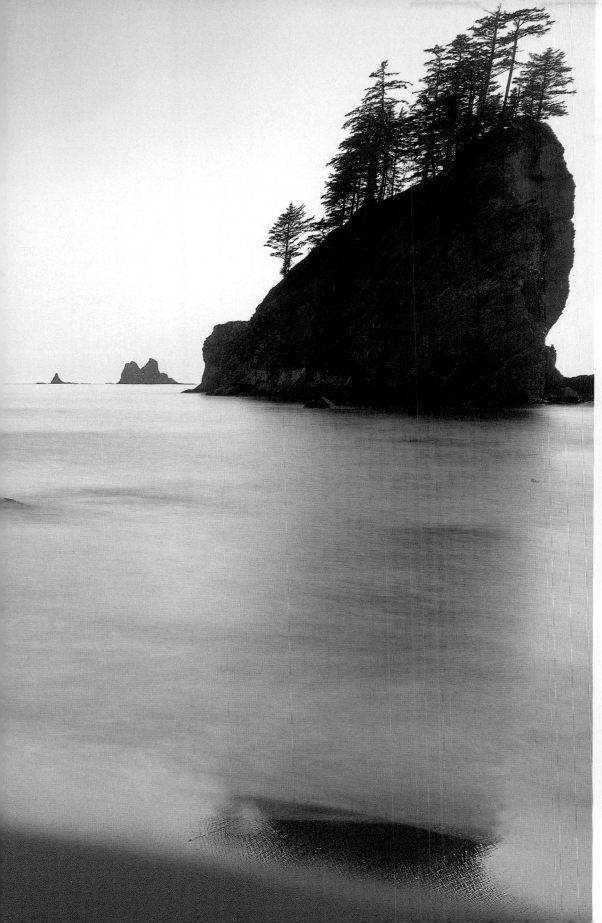

Sea Wolf petroglyph, Gabriola Island, British Columbia

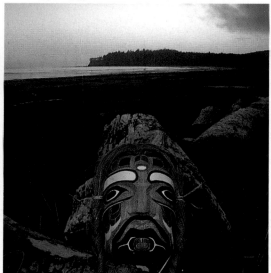
Makah mask by Frank Smith, Neah Bay, Washington

Multicolored starfish, Olympic National Park, Washington

Seastacks, Second Beach, Olympic National Park, Washington

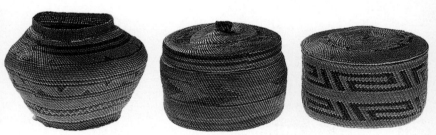

Makah baskets, Washington, courtesy San Diego Museum of Man

Makah cedar dugout canoes, Makah Cultural and
Research Center, Neah Bay, Washington

Dugout canoes were the main form of transportation for the Northwest Coast people. Small canoes were used for navigating the rocky coastline. Large seagoing canoes, up to 70 feet long, were the specialty of the Haida, who traded them to other tribes.

Each canoe was made from a log hollowed out by controlled burning. High projections at the front and back, which helped stabilize the canoe in rough waters, were probably carved separately and sewn to the body. The wide, curved sides were created using steam. The partially built canoe was filled with water, into which superheated rocks were dropped. The resulting steam softened the wood, allowing the builders to force in stretching posts of gradually increasing size. Painted floats were made of inflated seal skins. The bow was often painted with crest designs, as were the paddles, which doubled as weapons.

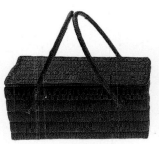

Northern Coast Salish basket box, British Columbia, courtesy San Diego Museum of Man

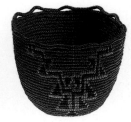

Nisqually or Cowlitz basket, Washington, courtesy San Diego Museum of Man

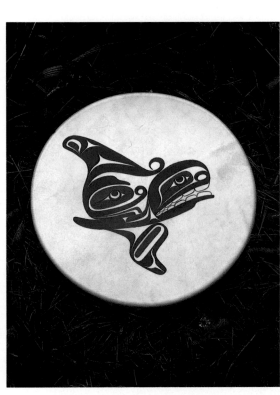

Makah drum by John Goodwin, Washington

Makah drum by Steve Pendleton, Washington

Northwest Coast drum and beater, courtesy San Diego Museum of Man

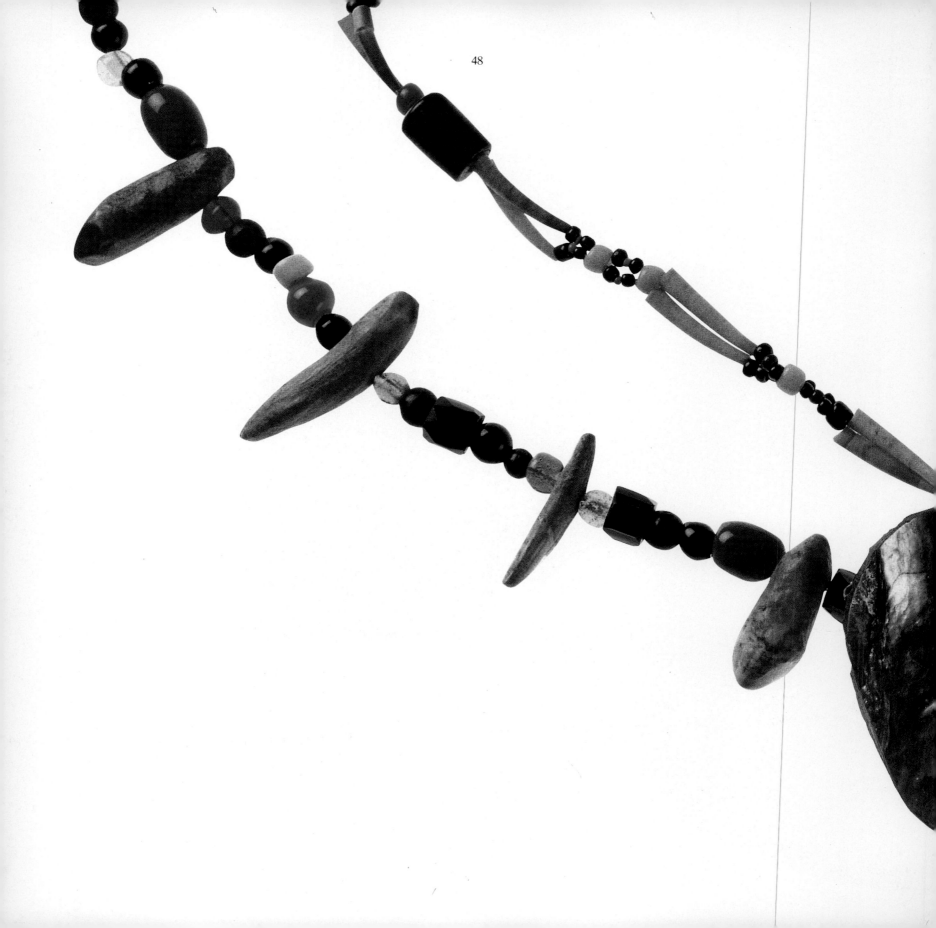

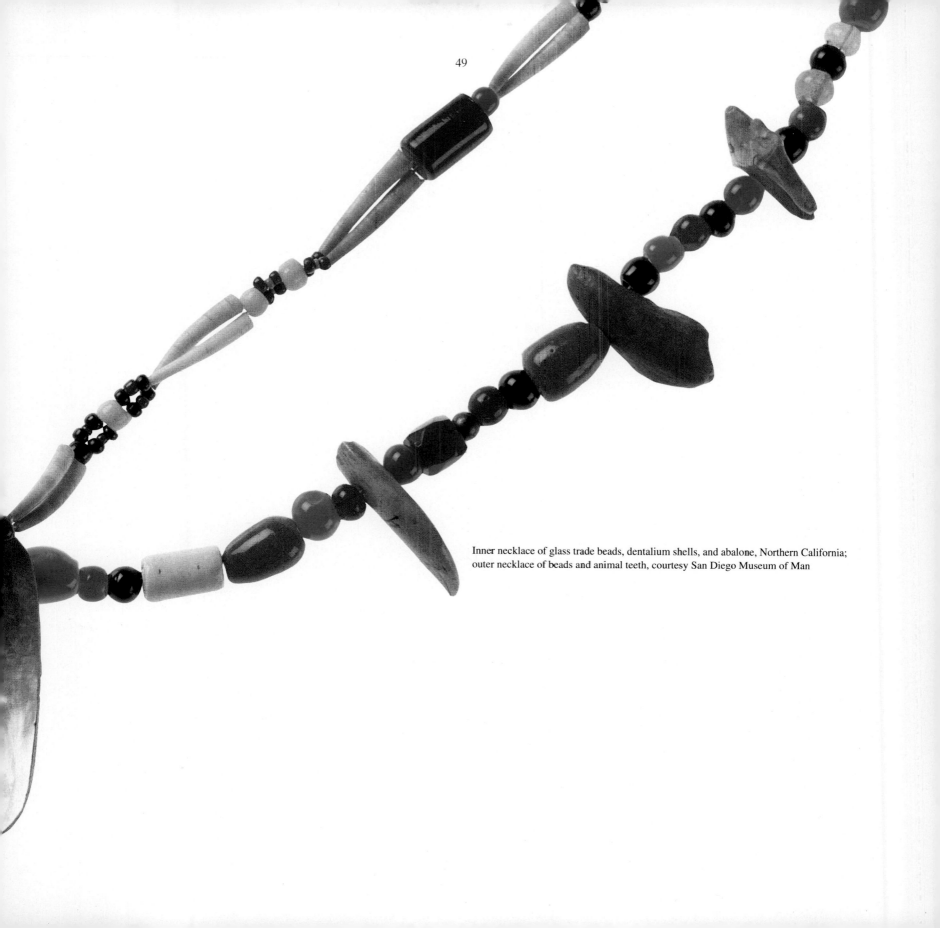

Inner necklace of glass trade beads, dentalium shells, and abalone, Northern California; outer necklace of beads and animal teeth, courtesy San Diego Museum of Man

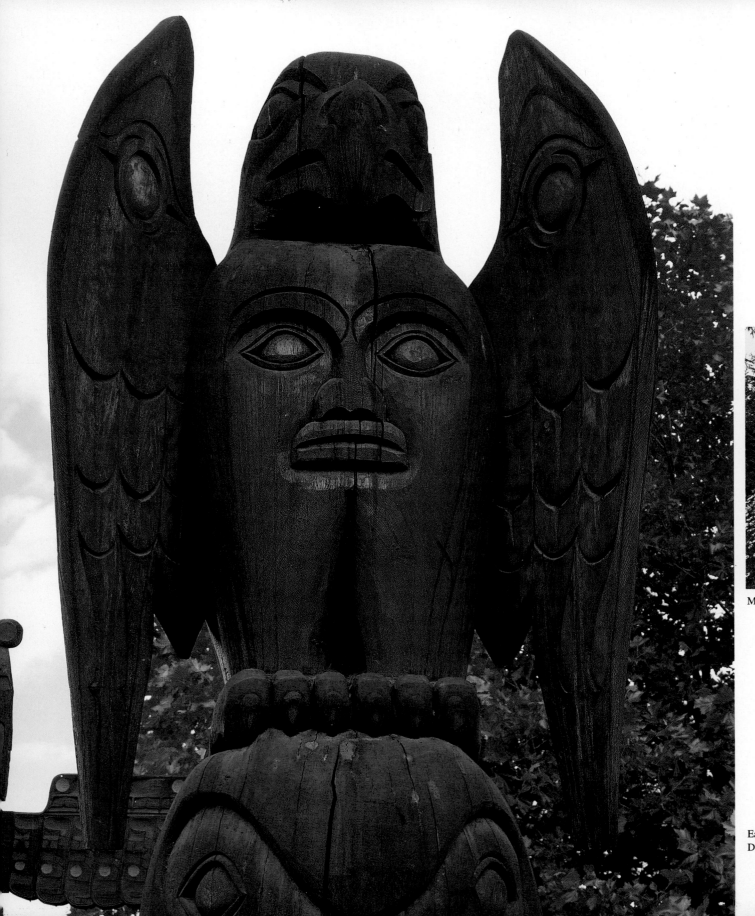

Makah memorial pole, Washington

Eagle with face carving,
Duncan, British Columbia

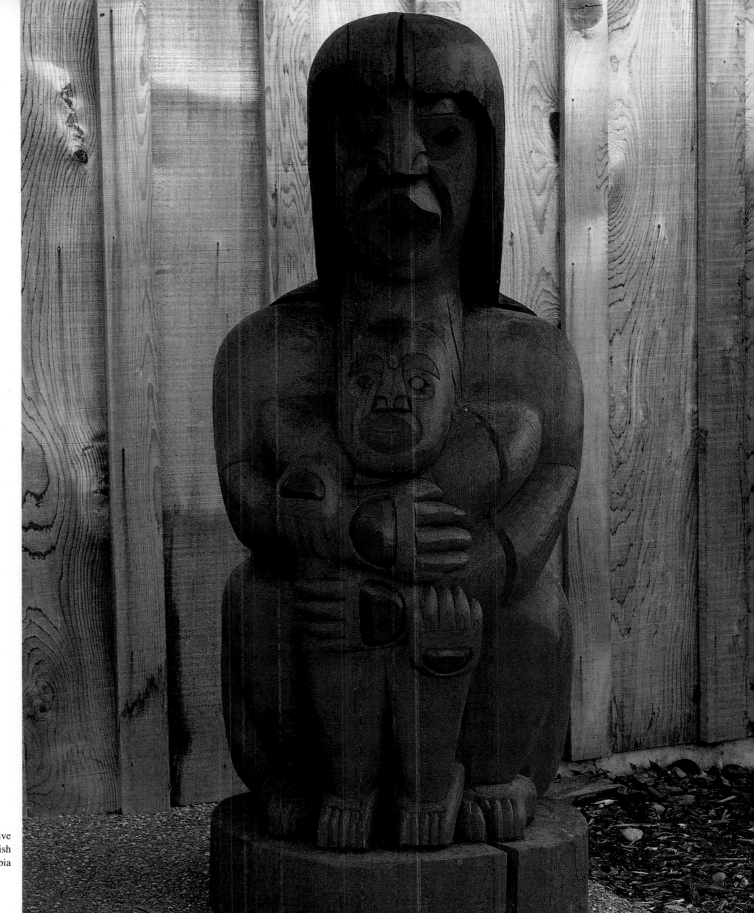

Mother and child carving, Native Heritage Center, Duncan, British Columbia

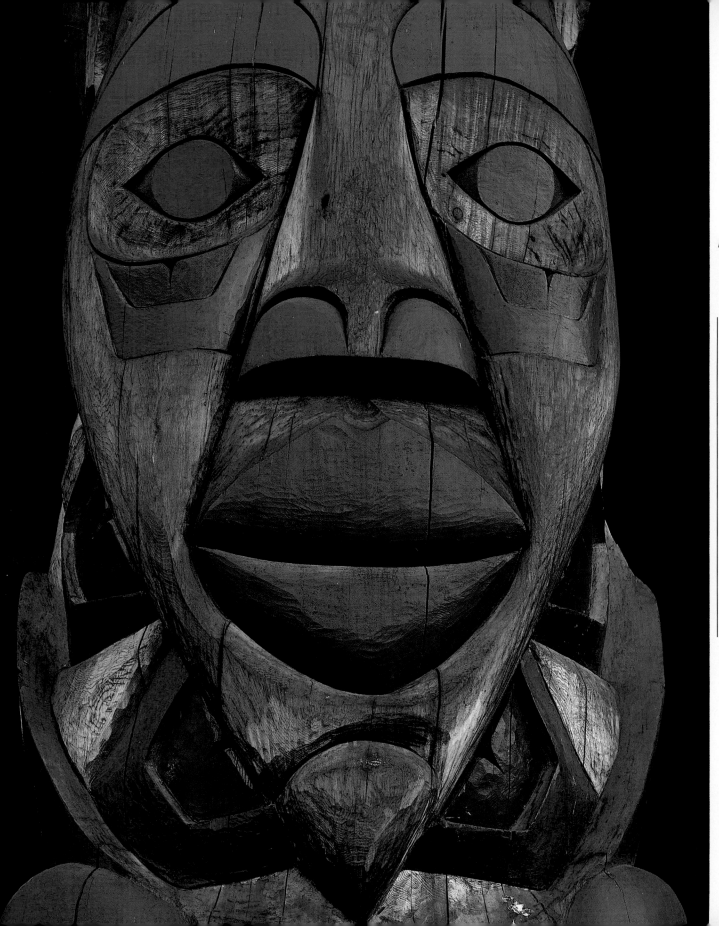

The most common type of totem pole is the memorial pole, raised at a potlatch by a chief's heir when he assumed the chief's titles. The sculptural figures, which flow into each other seamlessly, are family crests. Shorter mortuary poles, the height of one or two carved figures, often supported the grave boxes of Haida notables. Interior house posts and exterior frontal poles were also carved and painted.

Totem detail, Native Heritage Center, Duncan, British Columbia

Yax-Te totem pole, Auke Bay, Alaska

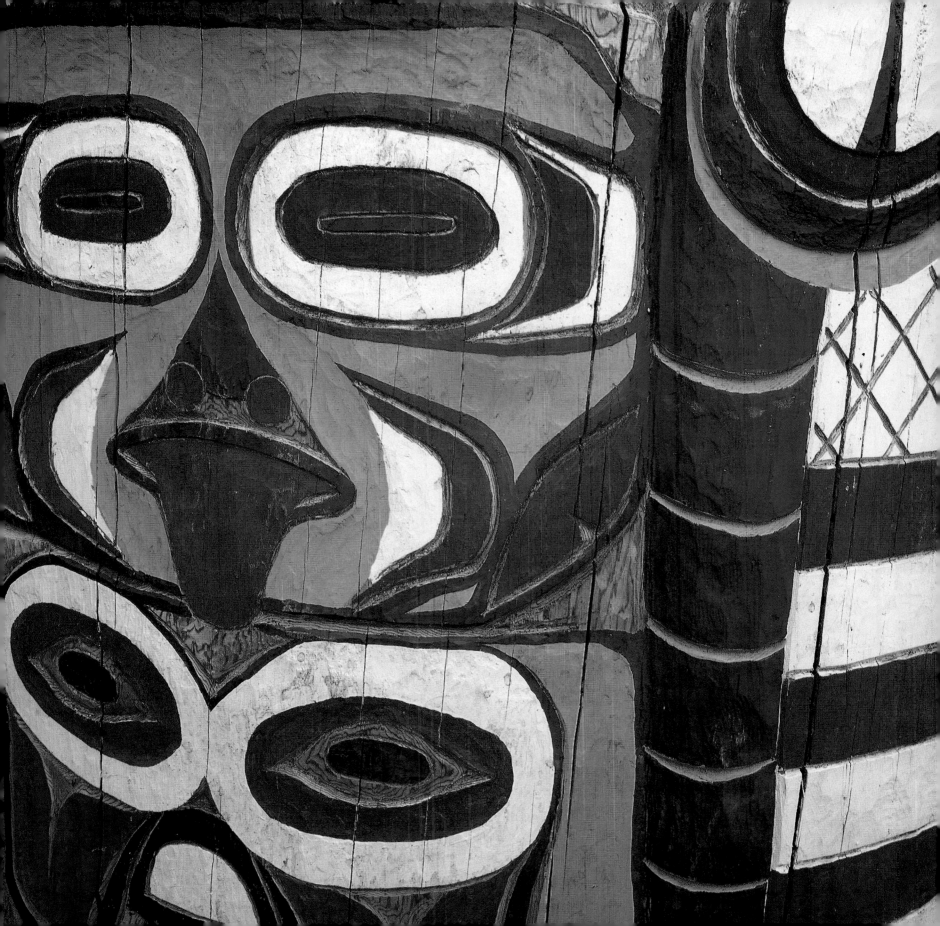

Kwakiutl mask, British Columbia,
courtesy San Diego Museum of Man

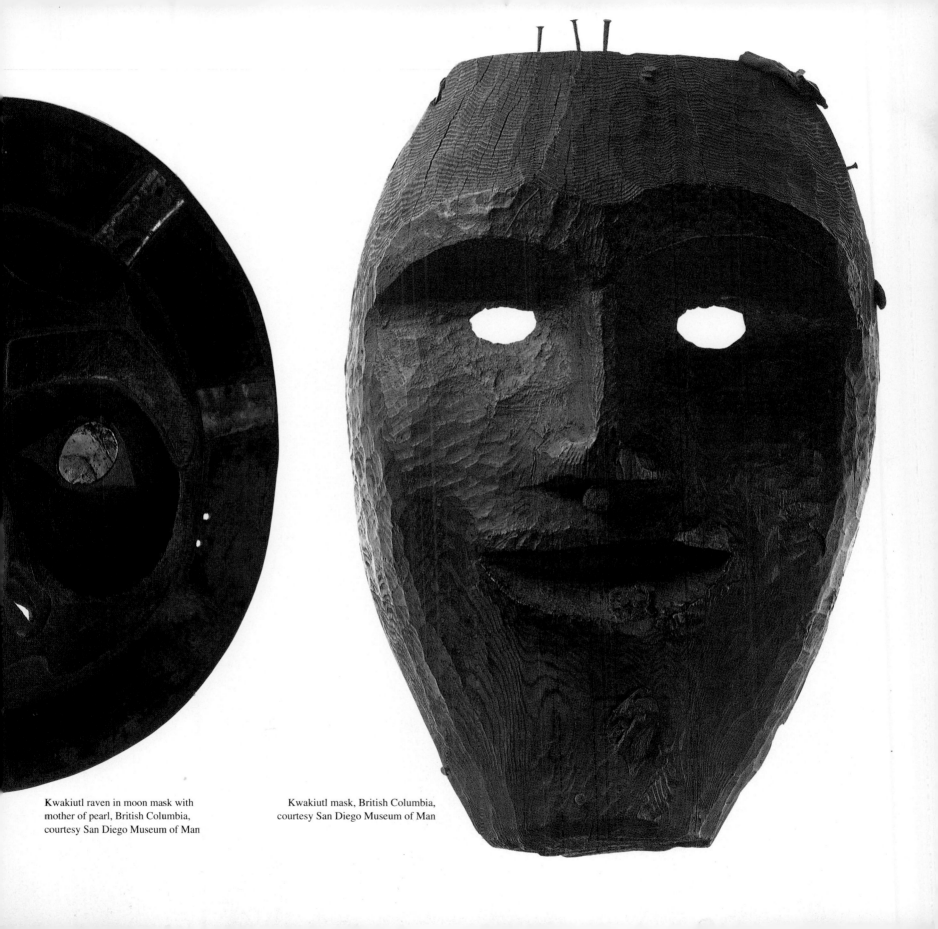

Kwakiutl raven in moon mask with
mother of pearl, British Columbia,
courtesy San Diego Museum of Man

Kwakiutl mask, British Columbia,
courtesy San Diego Museum of Man

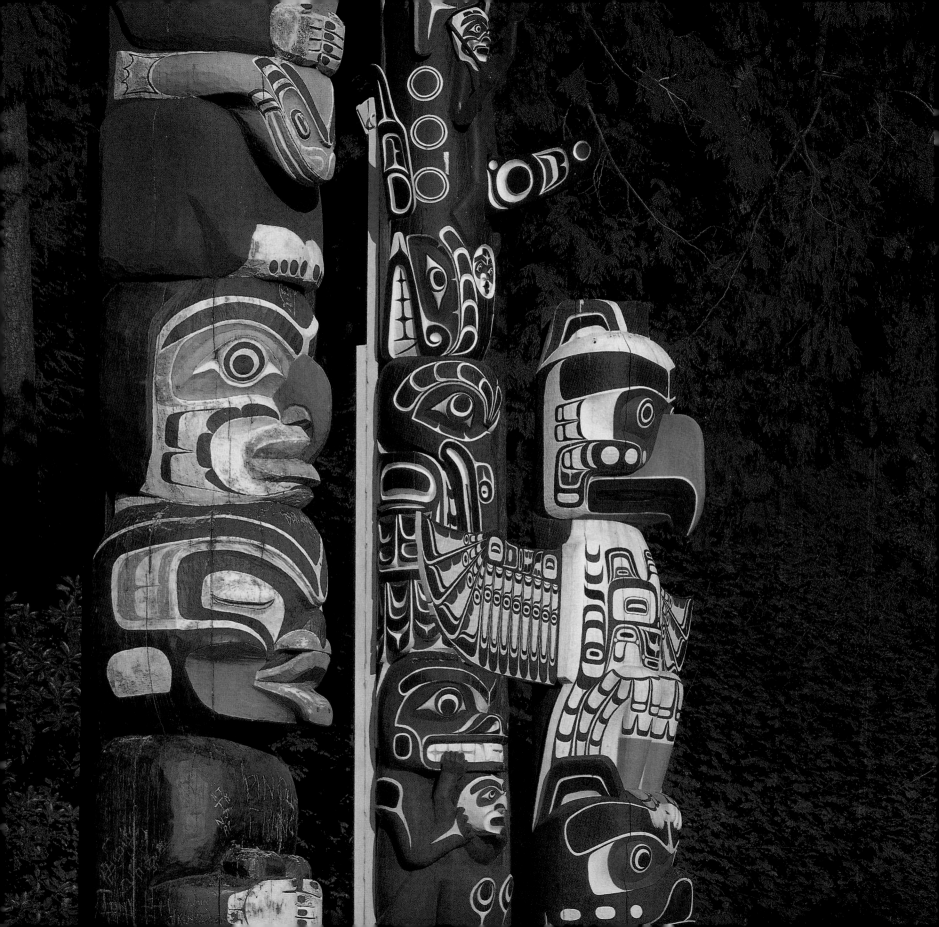

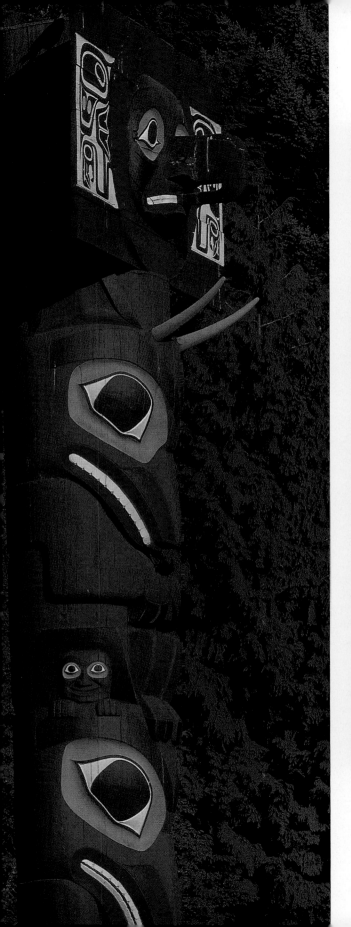

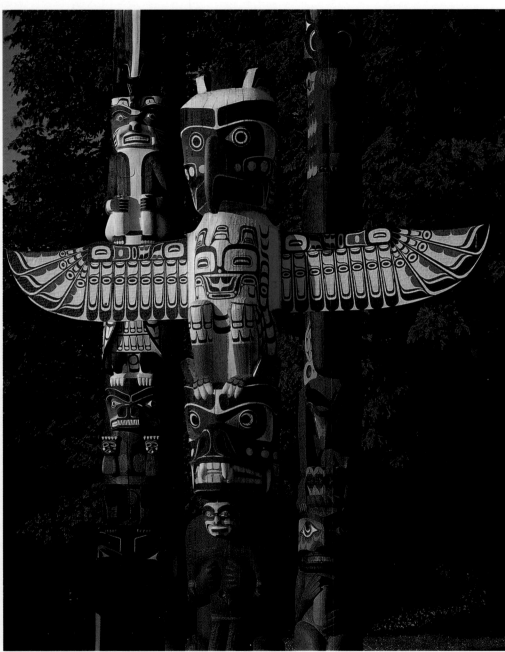

Totems at Stanley Park, Vancouver, British Columbia

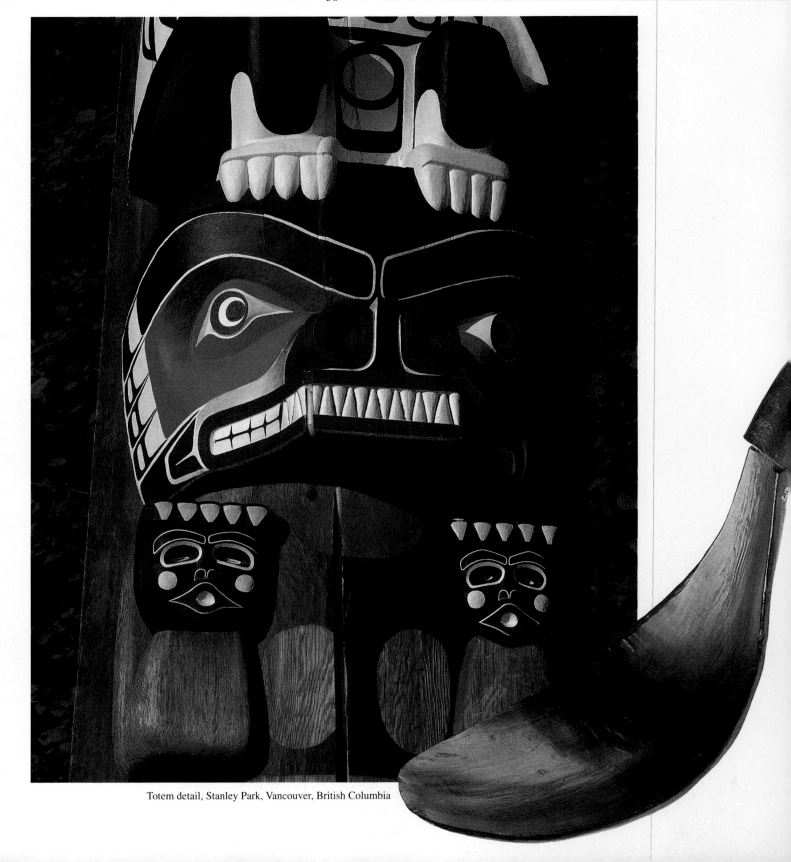

Totem detail, Stanley Park, Vancouver, British Columbia

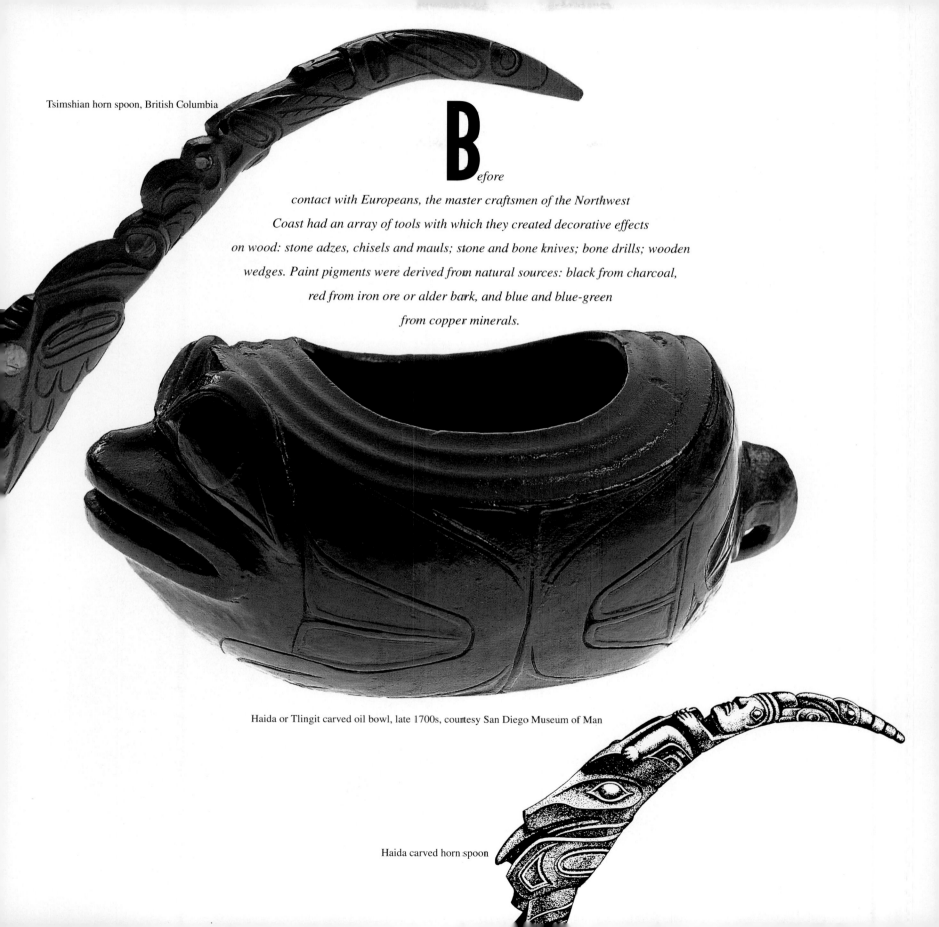

Tsimshian horn spoon, British Columbia

Before contact with Europeans, the master craftsmen of the Northwest Coast had an array of tools with which they created decorative effects on wood: stone adzes, chisels and mauls; stone and bone knives; bone drills; wooden wedges. Paint pigments were derived from natural sources: black from charcoal, red from iron ore or alder bark, and blue and blue-green from copper minerals.

Haida or Tlingit carved oil bowl, late 1700s, courtesy San Diego Museum of Man

Haida carved horn spoon

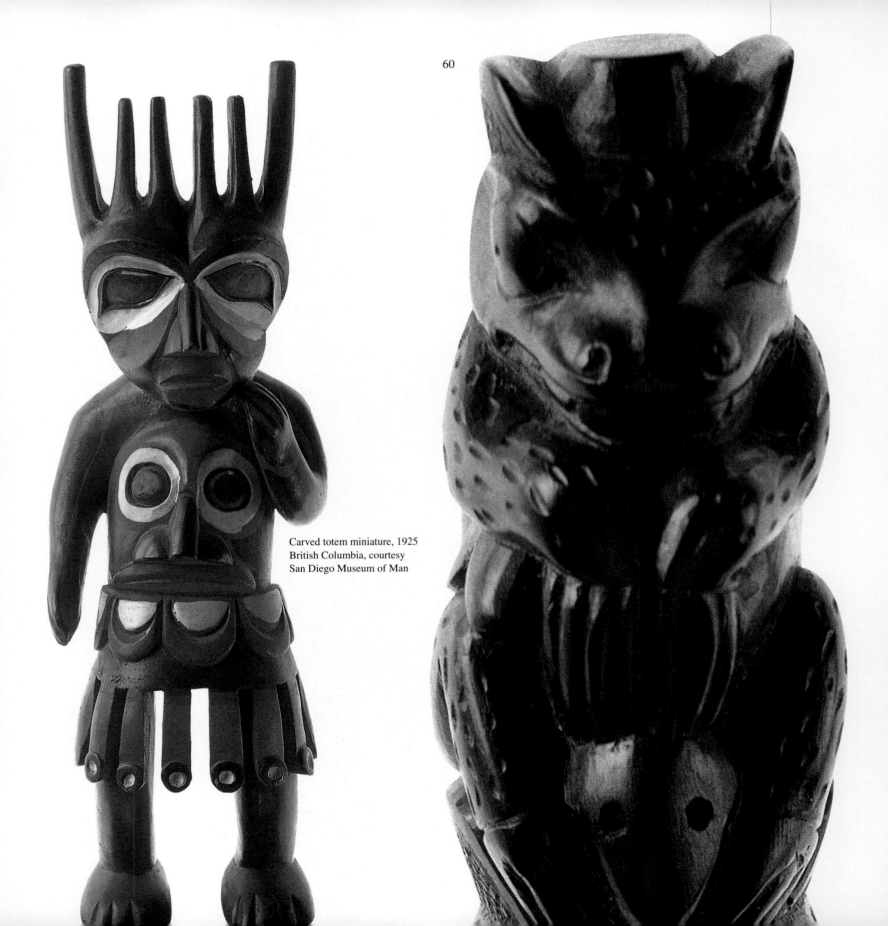

Carved totem miniature, 1925
British Columbia, courtesy
San Diego Museum of Man

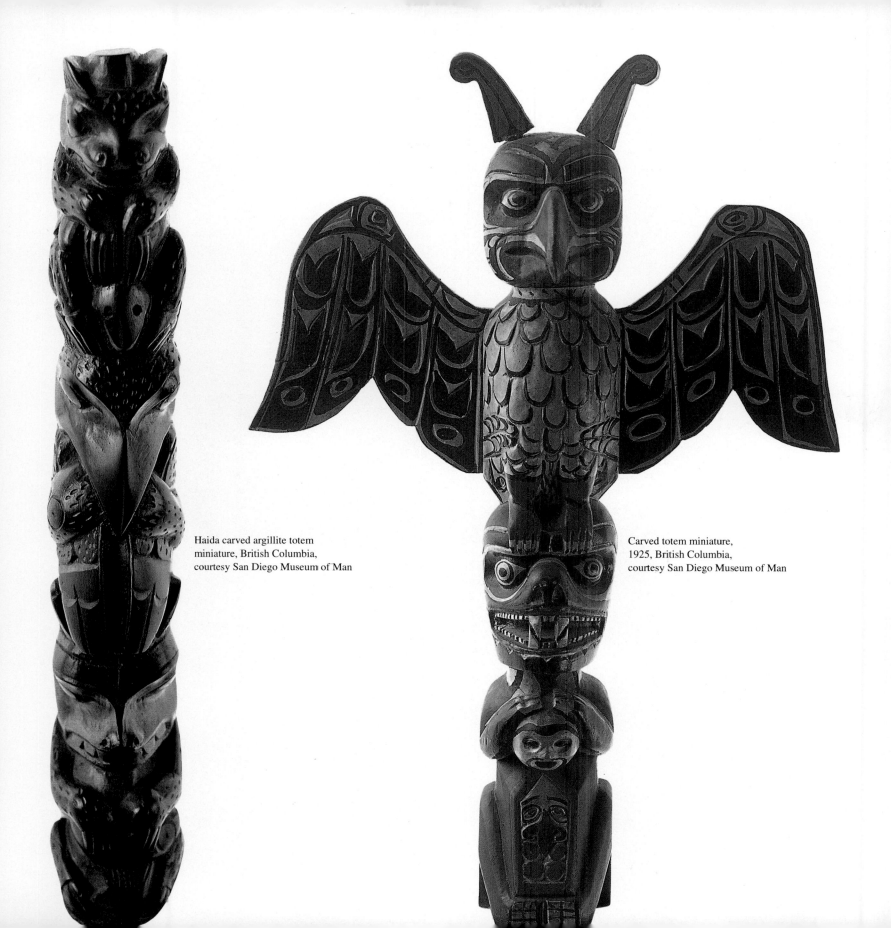

Haida carved argillite totem
miniature, British Columbia,
courtesy San Diego Museum of Man

Carved totem miniature,
1925, British Columbia,
courtesy San Diego Museum of Man

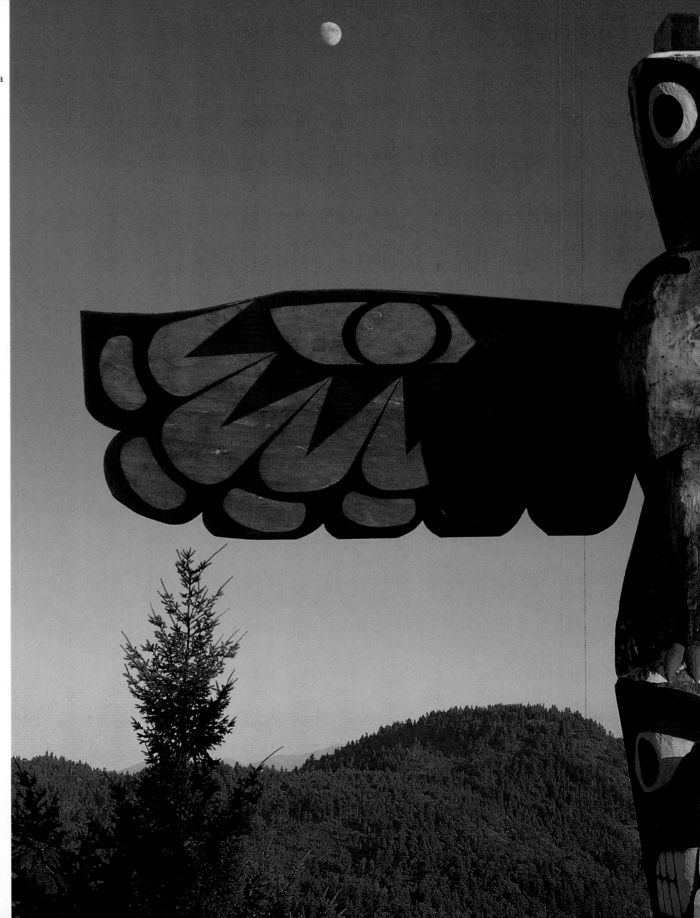

Totem, Vancouver Island, British Columbia

Haida totem poles
(after Swanton)

Eagle

Frog

Ancestor of
Eagle Clan

Frog

Eagle

Frog

Beaver

Frog

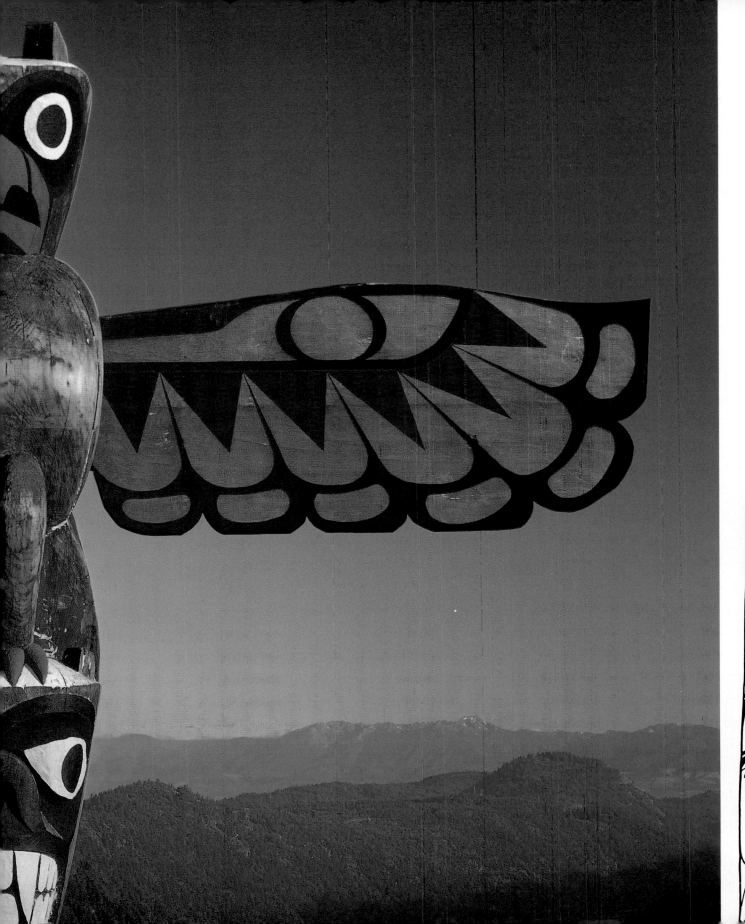

Raven with moon

Chief's dance hat

Frog

Raven stealing
Beaver's lake

Salmon in lake

Grandfather
of Raven

Raven

Crescent moon

Butterfly

Beaver

Raven

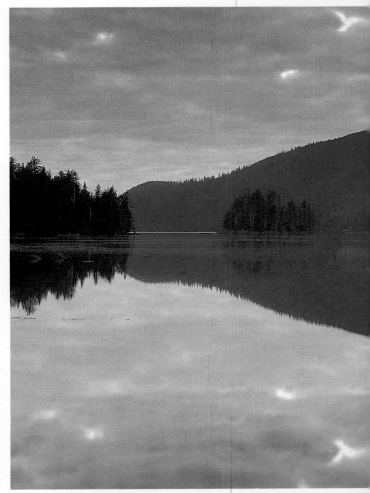

ach tribe of the Northwest Coast had its own dances and masks. Similar mythological stories would be enacted in unique ways up and down the coast. The great carved masks, worn during the winter ceremonials, seemed to come to life in the

Rose Harbor, South Moresby National Park, British Columbia

Kwakiutl face mask, courtesy San Diego Museum of Man

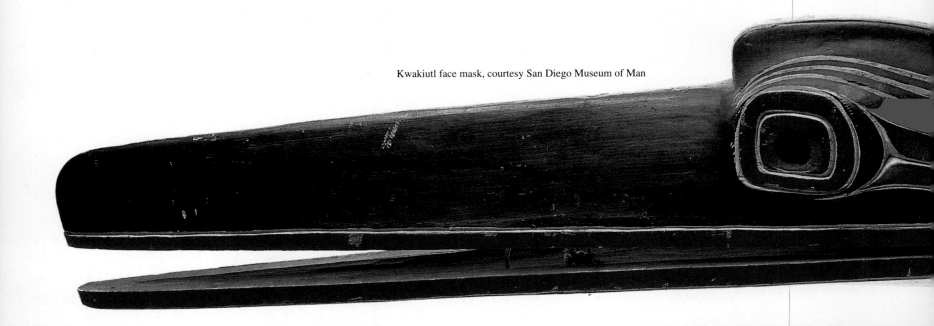

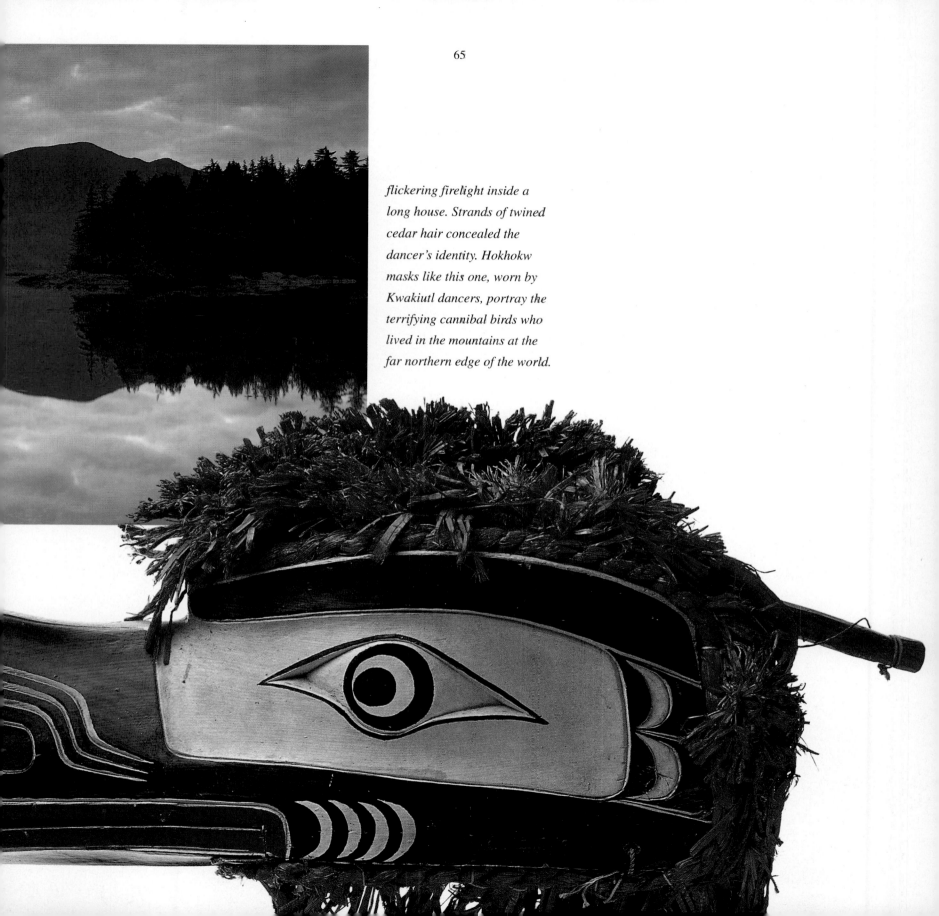

65

flickering firelight inside a
long house. Strands of twined
cedar hair concealed the
dancer's identity. Hokhokw
masks like this one, worn by
Kwakiutl dancers, portray the
terrifying cannibal birds who
lived in the mountains at the
far northern edge of the world.

The European colonists who came to this coast brought progress of a kind that almost destroyed the old cultures. Laws prohibiting the potlatch were enacted in both the United States and Canada. Introduced diseases such as smallpox eradicated some villages and decimated others. Many areas were abandoned as the survivors gathered

Ancient Haida burial poles at
the abandoned village of Ninstints

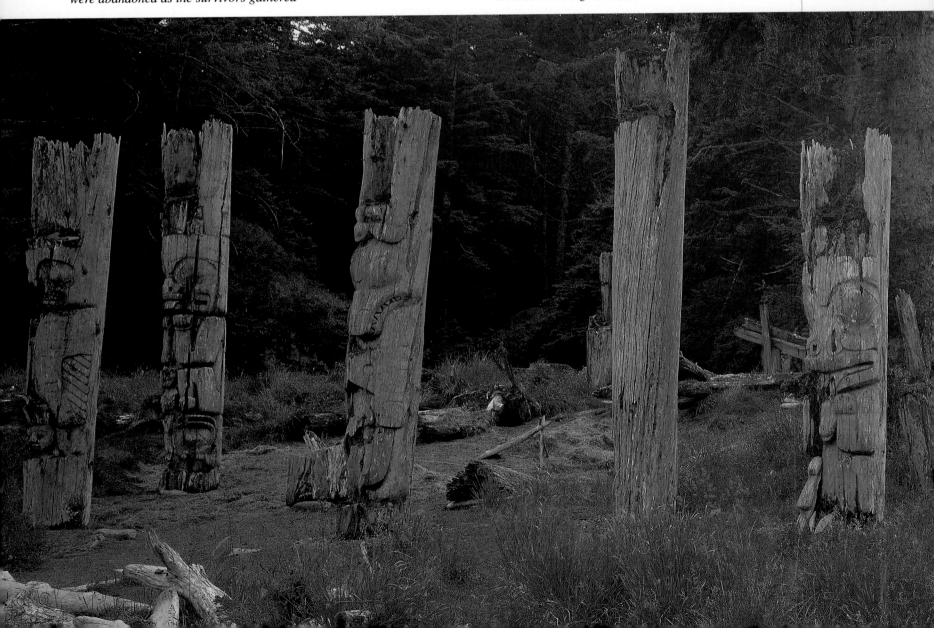

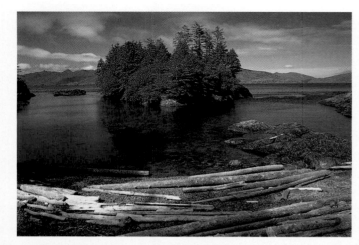

View from Ninstints

elsewhere. The Haida village of Ninstints on Anthony Island in the Queen Charlottes, abandoned in the early twentieth century, was declared a World Heritage site by UNESCO in 1981. Its monumental totem poles, some fallen, some still standing, are a reminder of the accomplishments of a people almost vanished, now flourishing again in unexpected ways.

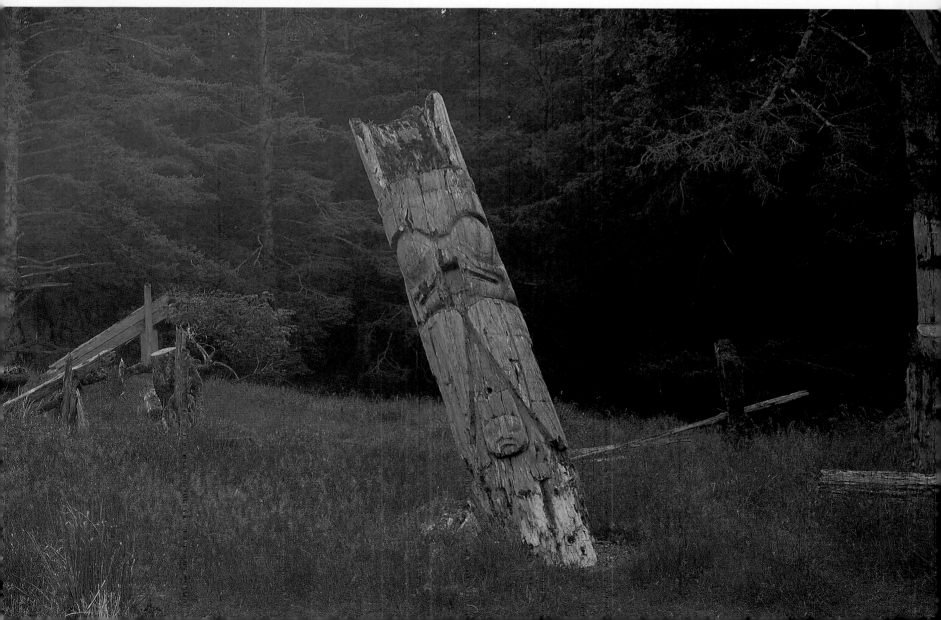

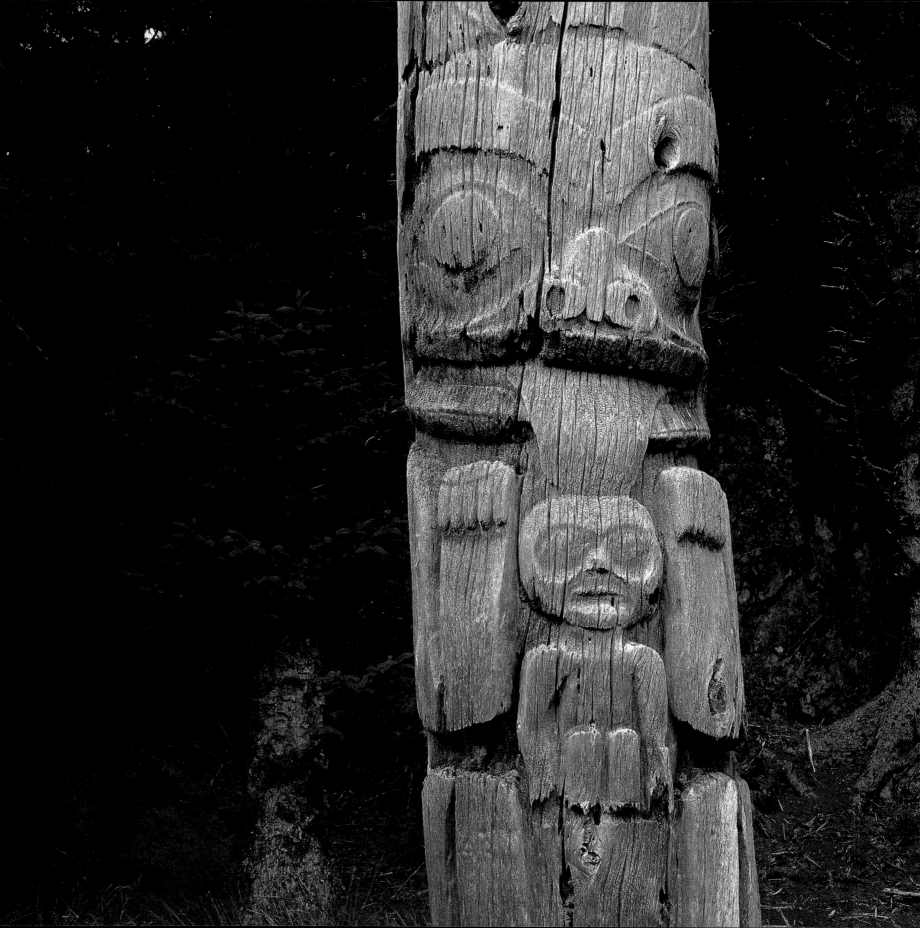

Totem detail of frog
Right: Totem detail of bear's eye
Left: Bear effigy and human

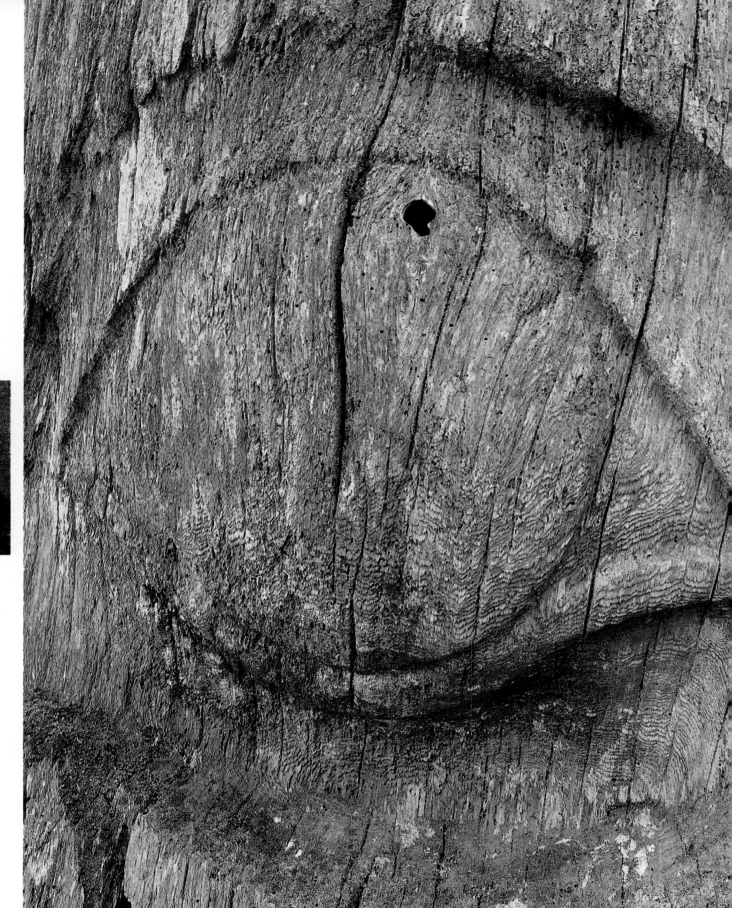

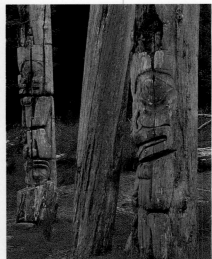

Above and right: Burial poles, Ninstints

Old Haida cedar dugout canoe, South Moresby
National Park, British Columbia

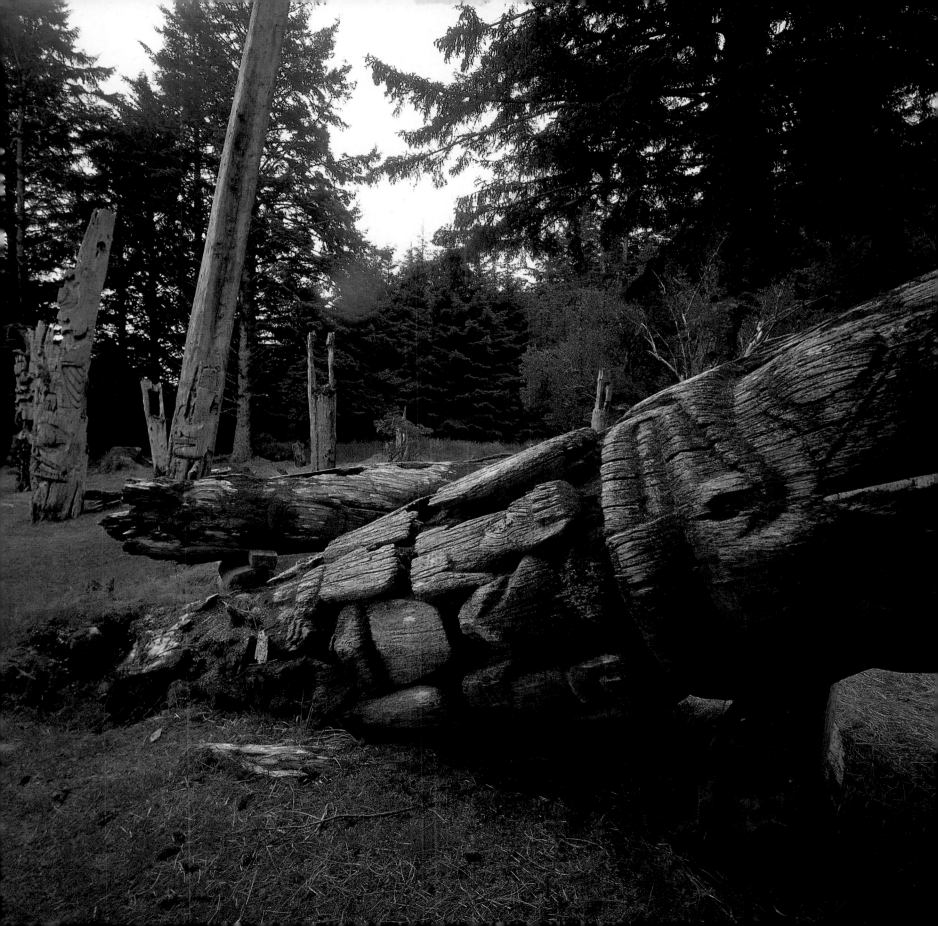

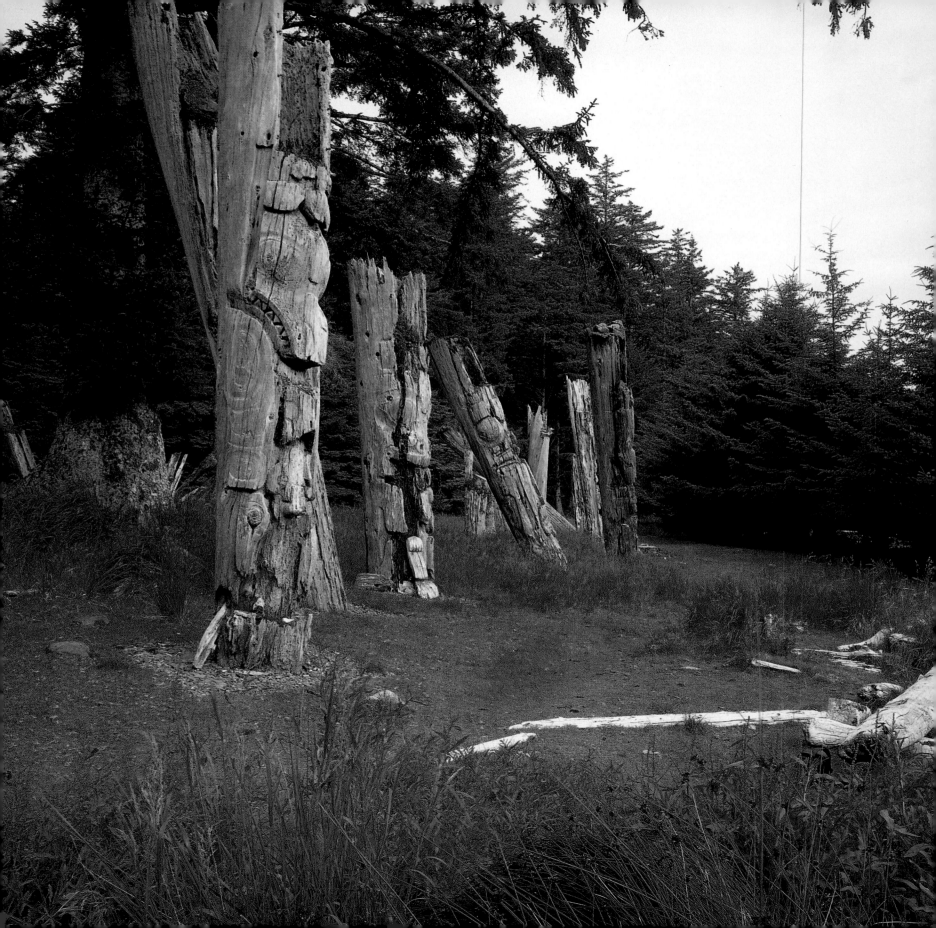

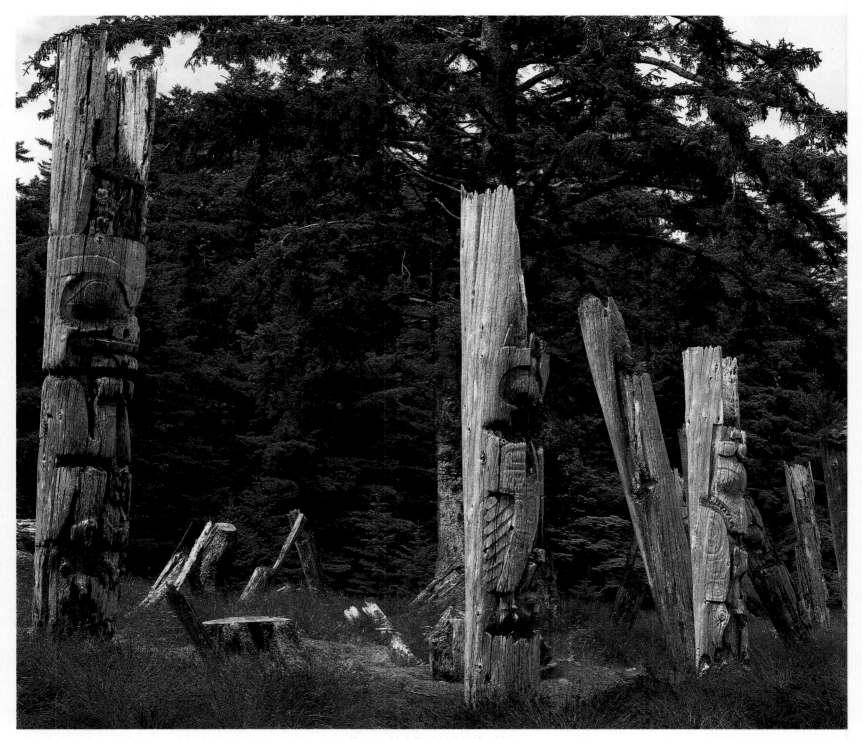

Above and left: Burial poles, Ninstints

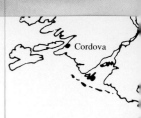

GULF OF
ALASKA

edge of Haida culture, while Davidson believes his art springs directly from his active participation in ceremonials and potlatches. Reid did not begin to explore his native heritage until he was a young man. His Haida mother had kept silent, well aware of the stigma of growing up Indian. Davidson made the connection earlier, learning to carve from his father and grandfather.

From 1958 to 1962, Reid and others worked at the University of British Columbia, recreating a Haida village complete with five carved poles. In 1980 Davidson helped start the Rainbow Creek Dancers, who perform both traditional and new songs and dances at ceremonial gatherings. Each man has been responsible for the raising of a new totem pole in the Queen Charlottes, the first poles raised in a century. Reid's, completed in 1978, is at Skidegate, his mother's village; Davidson's, raised nine years earlier, is at Massett, his grandparents' village.

Although their approaches differ, each has pushed the northern style beyond its original bounds. Their work has inspired hundreds of young artists now training through apprenticeships; through classes at Kitanmax School of Northwest Coast Arts; and through slow, careful study of the work of masters. Far from dying out, Northwest Coast culture and art continue, in a transformative dialogue that enriches participant and observer alike.

Glacier Bay National Park, Alaska

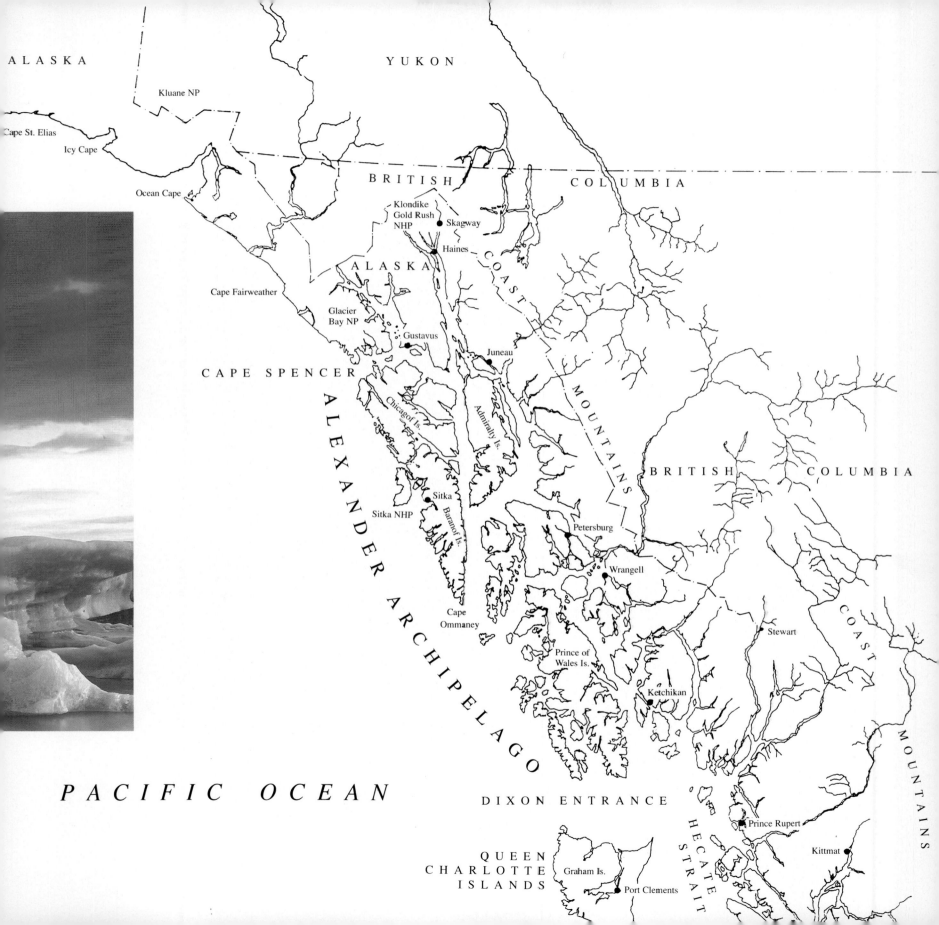

ALASKA

Kluane NP

Cape St. Elias

Icy Cape

Ocean Cape

YUKON

B R I T I S H C O L U M B I A

Klondike
Gold Rush
NHP

Skagway

Haines

A L A S K A

Cape Fairweather

Glacier
Bay NP

Gustavus

Juneau

CAPE SPENCER

A L E X A N D E R A R C H I P E L A G O

Chicagof Is.

Admiralty Is.

C O A S T

M O U N T A I N S

B R I T I S H C O L U M B I A

Sitka

Sitka NHP

Baranof Is.

Petersburg

Wrangell

Stewart

Cape
Ommaney

Prince of
Wales Is.

Ketchikan

C O A S T

PACIFIC OCEAN

DIXON ENTRANCE

Prince Rupert

M O U N T A I N S

QUEEN
CHARLOTTE
ISLANDS

Graham Is.

Port Clements

H E C A T E

S T R A I T

Kittmat

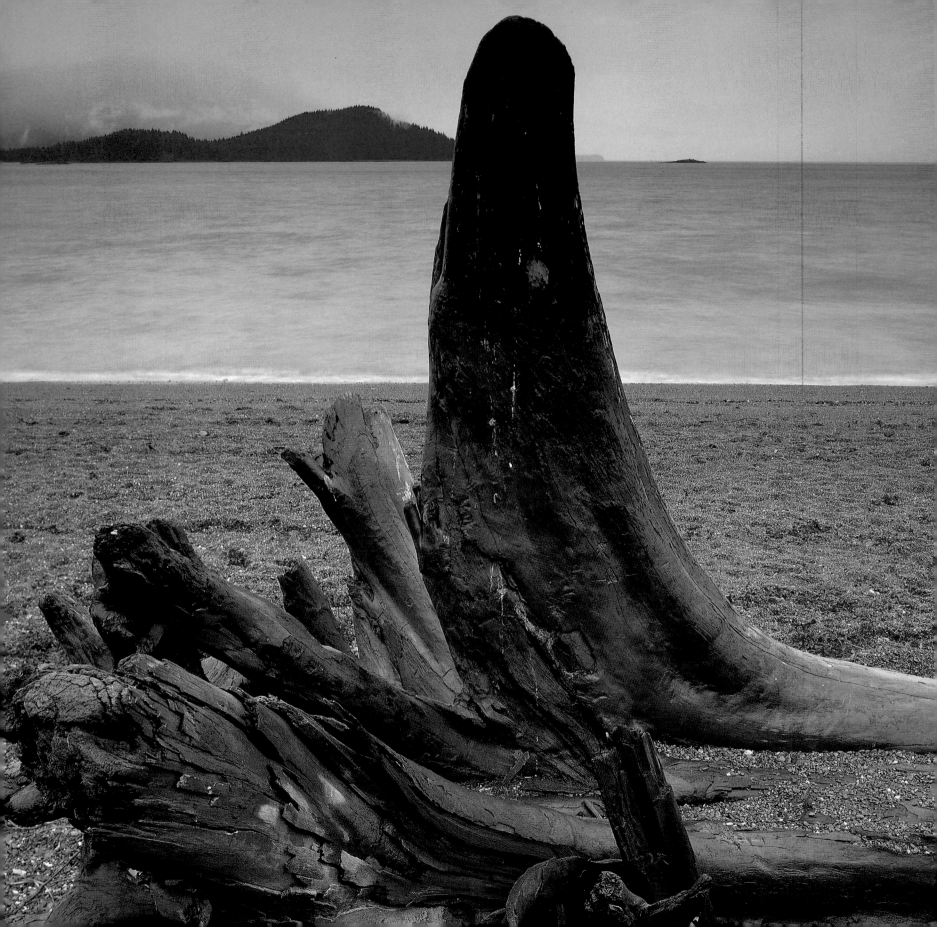

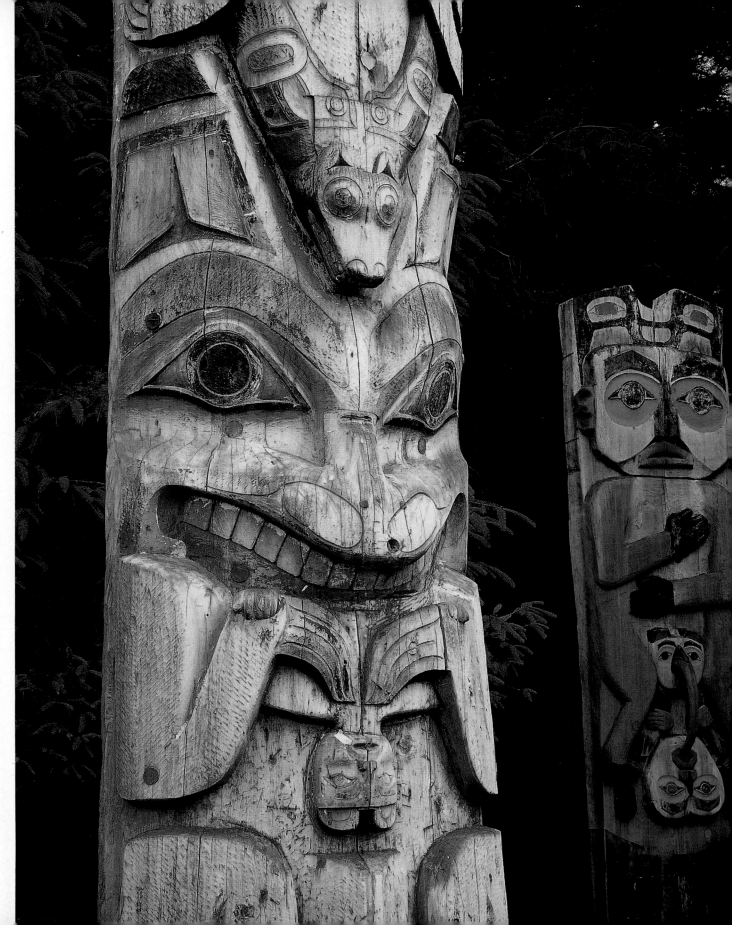

F

or most, the Far North conjures up images of year-round snow and ice. In reality, the weather along the Northwest coast is tempered by the Pacific Ocean. The land is home to a diverse flora and fauna in the long summer days. The influence of nature in choice of subject and materials is evident everywhere in Northwest Coast art.

Saanaheit totem pole and house post, Sitka National Historic Park, Alaska. *Left:* Site of Auk Village, Auke Bay, Alaska

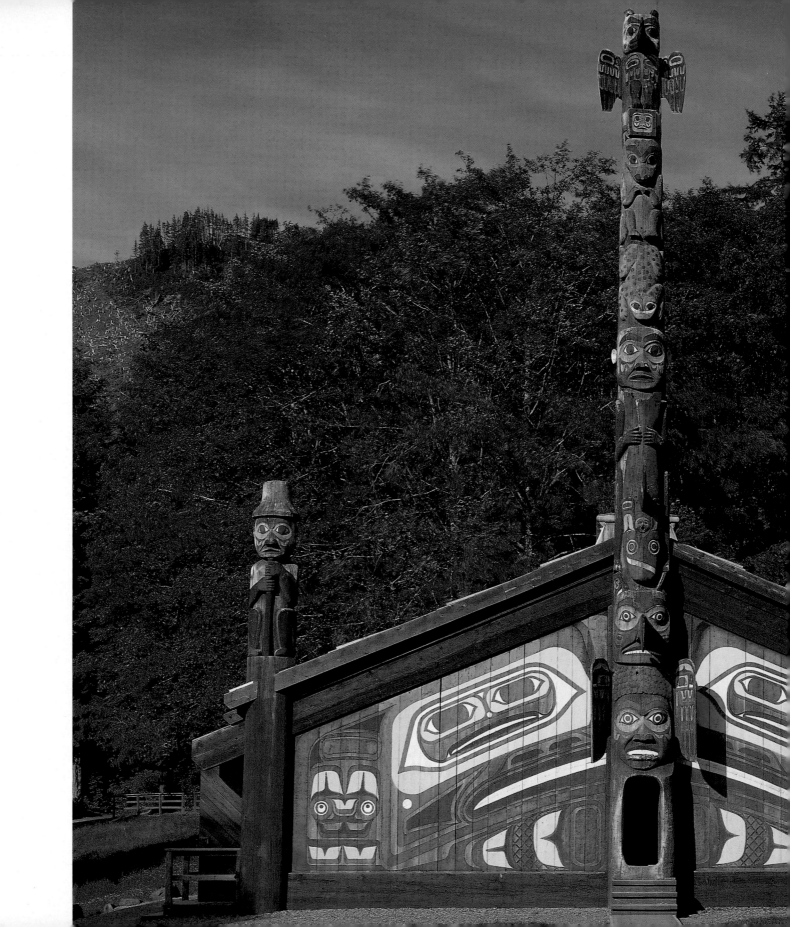

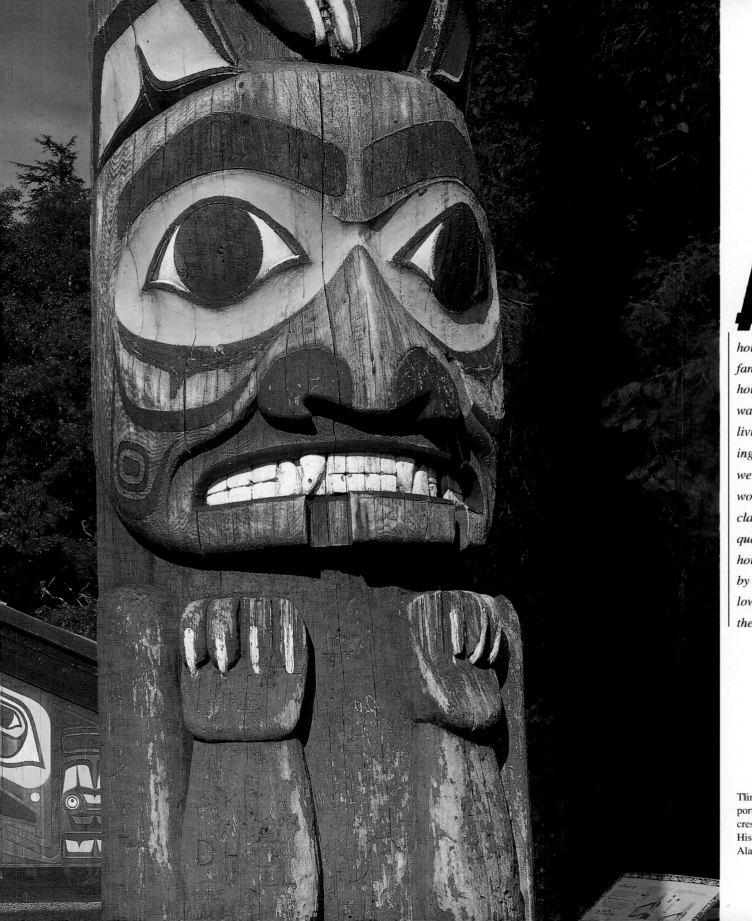

A typical 30- by 40-foot house was home to up to 10 families, all related to the house's owner. Low interior walls defined each family's living area. Personal belongings and ceremonial robes were stored in large bentwood boxes. The head of the clan's family had private quarters at the far end of the house, walled off or hidden by a painted screen. Those of lowest status slept closest to the door.

Tlingit-style clan house with central portal pole, carved corner poles, and crest poles, Totem Bight State Historic Park, near Ketchikan, Alaska

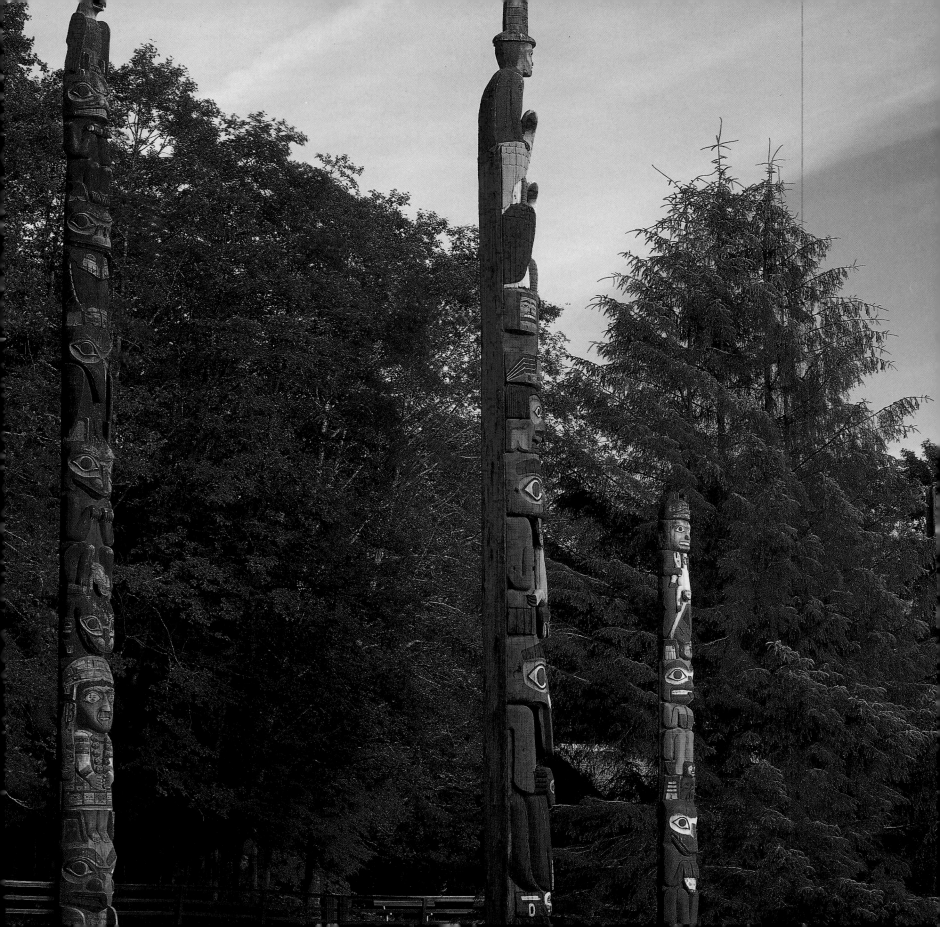

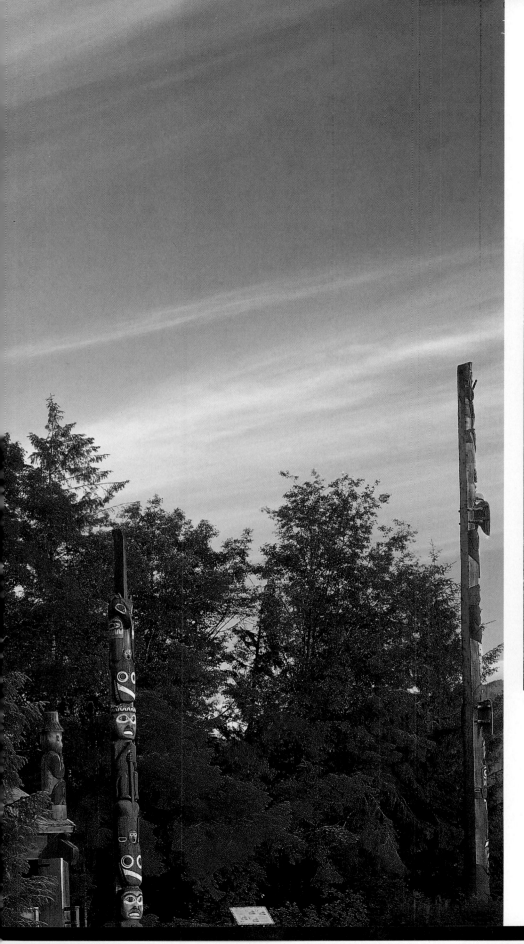

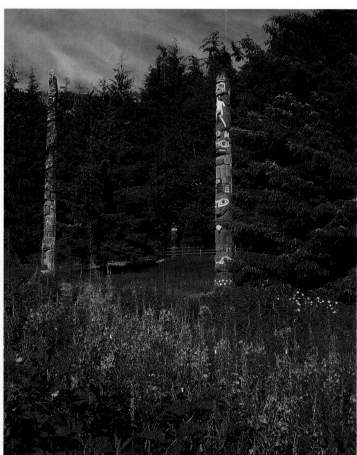

Totem Bight State Historic Park, Alaska

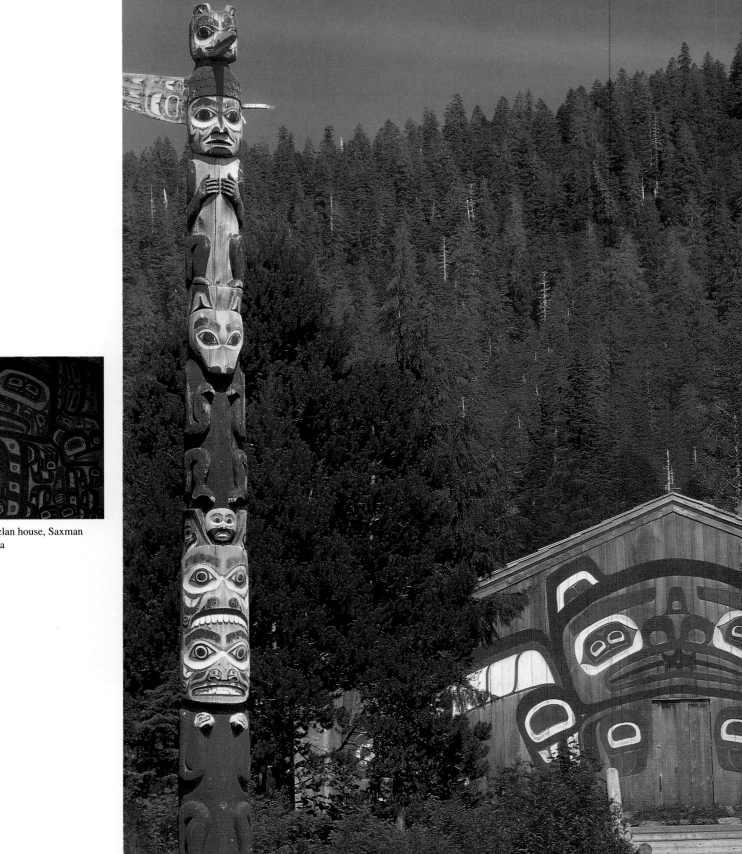

Above and far right: Interior of clan house, Saxman
Totem Village, Ketchikan, Alaska

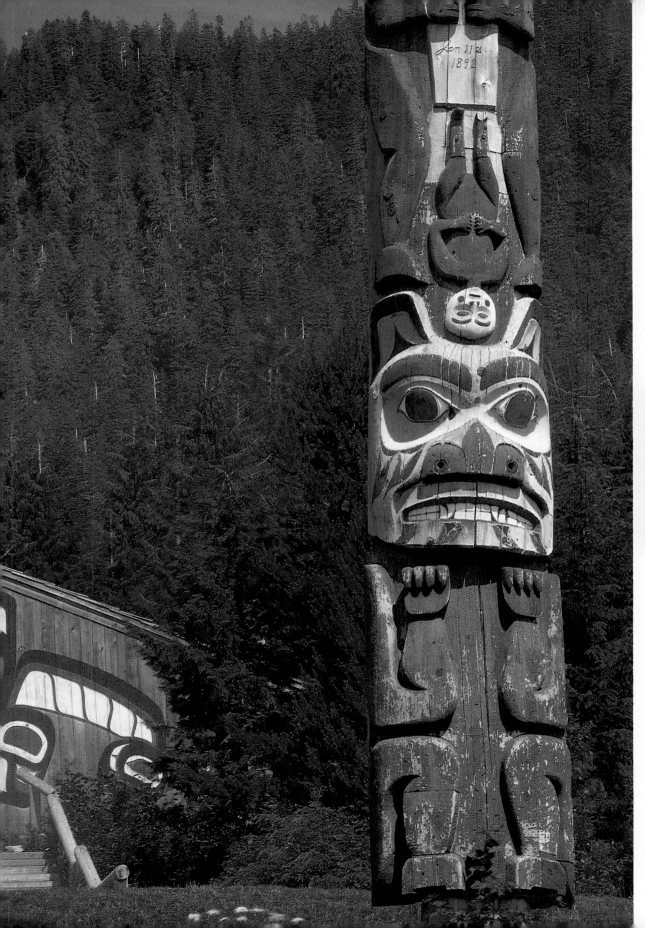

Tlingit clan house, Saxman Totem Village,
Ketchikan, Alaska

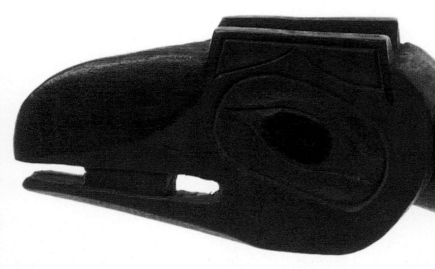

Tlingit shaman's raven rattle, 1890s, courtesy San Diego Museum of Man

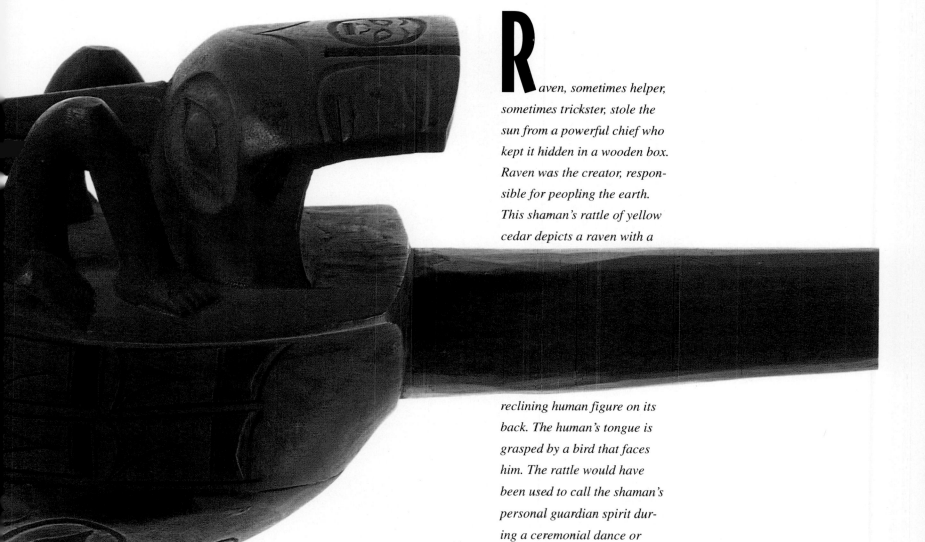

Raven, sometimes helper, sometimes trickster, stole the sun from a powerful chief who kept it hidden in a wooden box. Raven was the creator, responsible for peopling the earth. This shaman's rattle of yellow cedar depicts a raven with a

reclining human figure on its back. The human's tongue is grasped by a bird that faces him. The rattle would have been used to call the shaman's personal guardian spirit during a ceremonial dance or curing ritual.

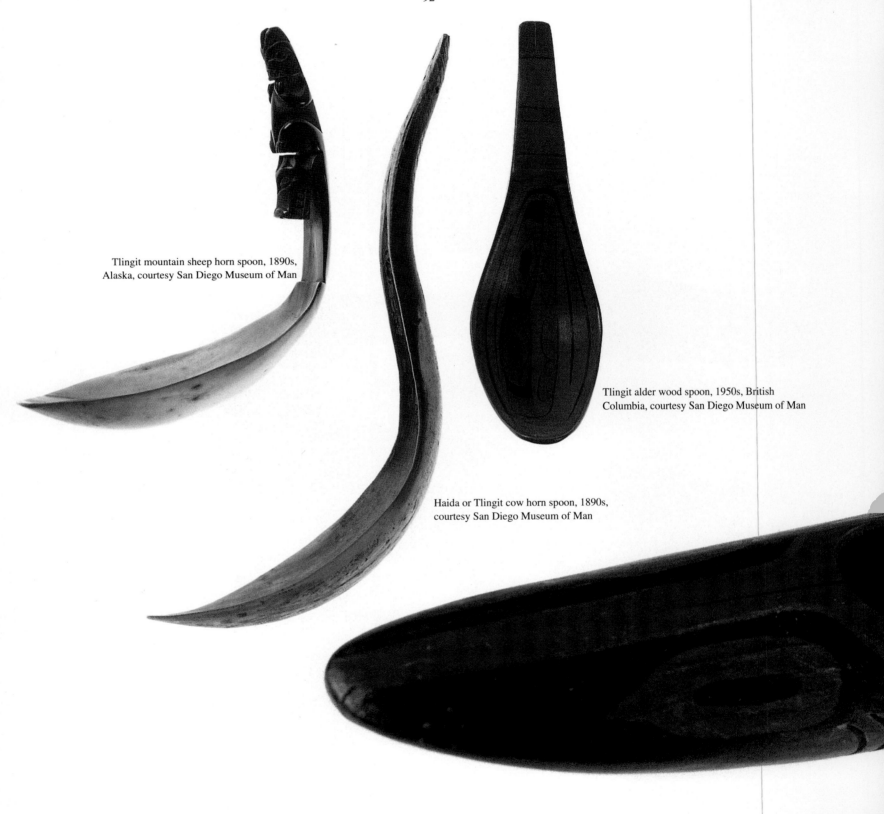

Tlingit mountain sheep horn spoon, 1890s, Alaska, courtesy San Diego Museum of Man

Tlingit alder wood spoon, 1950s, British Columbia, courtesy San Diego Museum of Man

Haida or Tlingit cow horn spoon, 1890s, courtesy San Diego Museum of Man

A*n*

assortment of household objects—ladles, spoons, a grease dish,

a fork—with their graceful curves and intricate surface decoration seem more like artworks than

items for everyday use. The drive to create beauty, inherent in all of us, was

expressed by the Northwest Coast peoples

in everything they made.

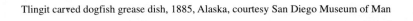

Tlingit carved dogfish grease dish, 1885, Alaska, courtesy San Diego Museum of Man

Cow horn spoon, Alaska,
courtesy San Diego Museum of Man

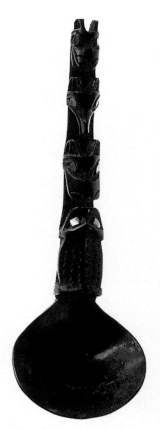

Totem horn spoon, courtesy
San Diego Museum of Man

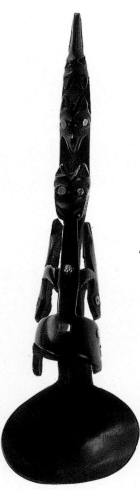

Tlingit carved horn spoon, 1900, Alaska,
courtesy San Diego Museum of Man

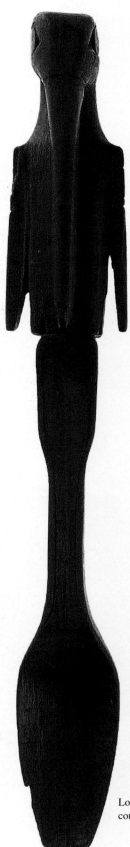

Long-billed wooden bird spoon,
courtesy San Diego Museum of Man

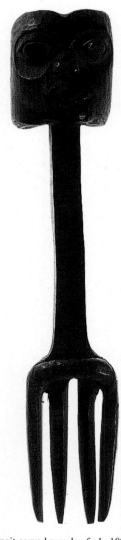

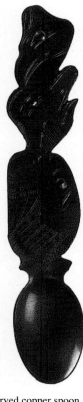

Tlingit carved copper spoon, 1890s,
Alaska, courtesy San Diego Museum of Man

Tlingit carved wooden fork, 1890s,
Alaska, courtesy San Diego Museum of Man

Haida carved mountain sheep and
mountain goat spoon, 1890s, British Columbia,
courtesy San Diego Museum of Man

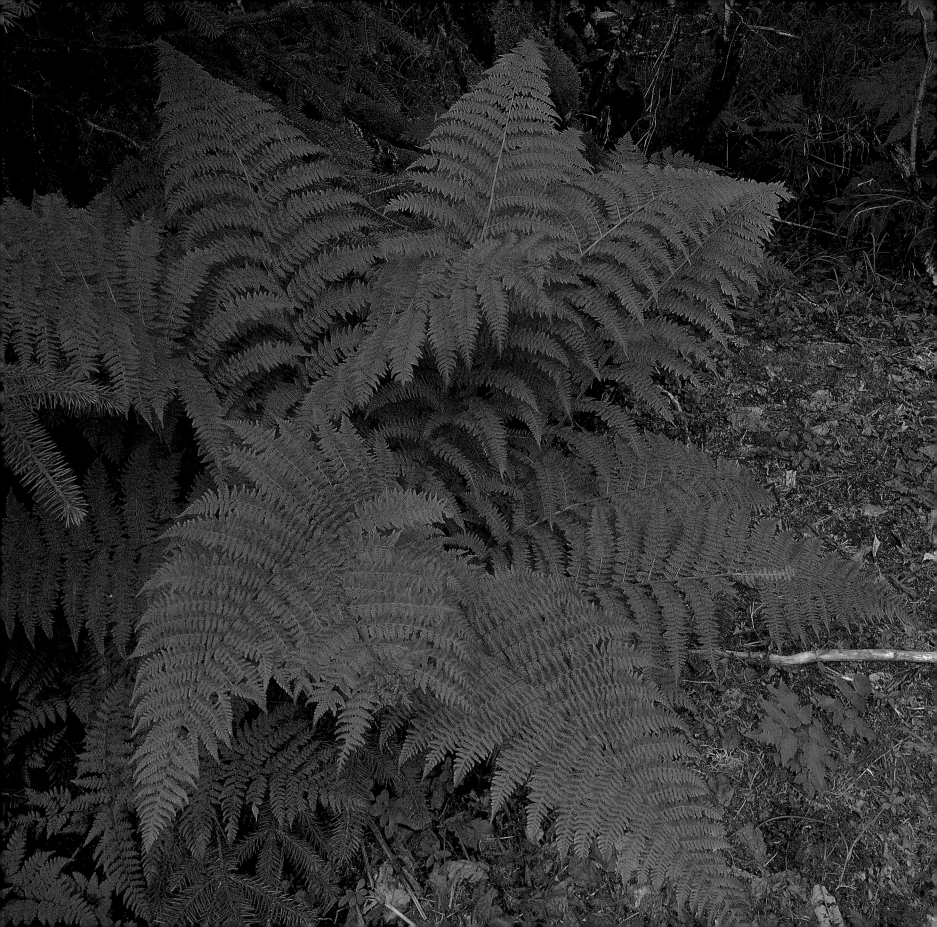

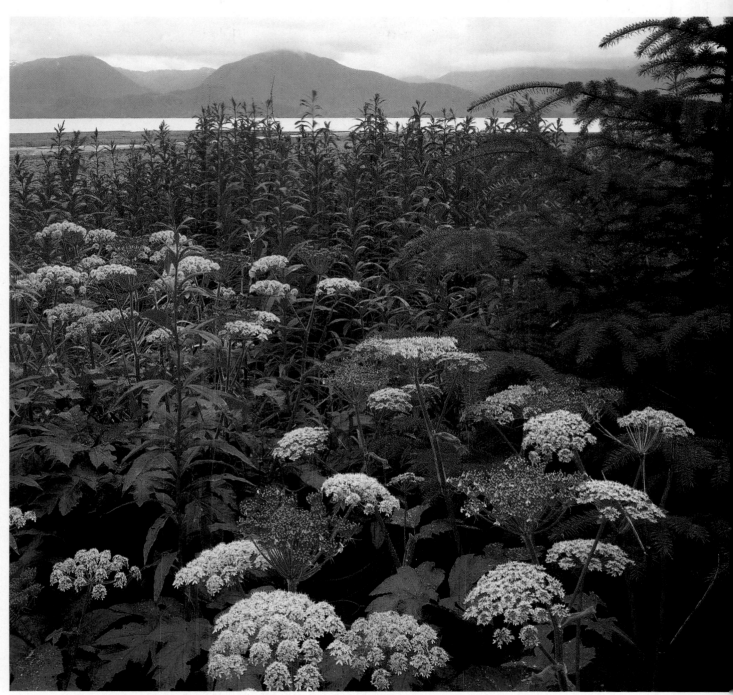

A tree falls in the forest. *Immediately it is attacked by the agents of decay—wood-digesting insects and fungi. As it breaks down over the next century, it becomes a nurse log, home to seedlings of many plant species, including trees that could not otherwise germinate on the water-saturated forest floor. Sometimes, as the young trees mature, their roots reach down around the nurse log to the ground. These arched reminders remain after the log has disintegrated completely.*

Site of Tlingit fort, Sitka National Historic Park, Alaska. *Left:* Tongass National Forest, Alaska

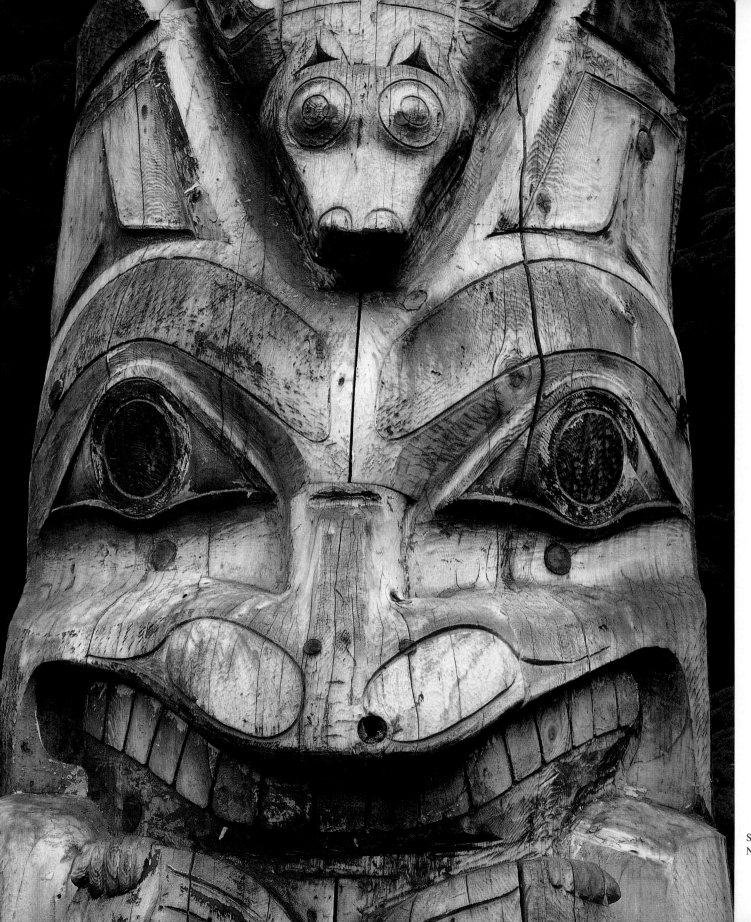

Saanaheit totem pole detail, Sitka
National Historic Park, Alaska

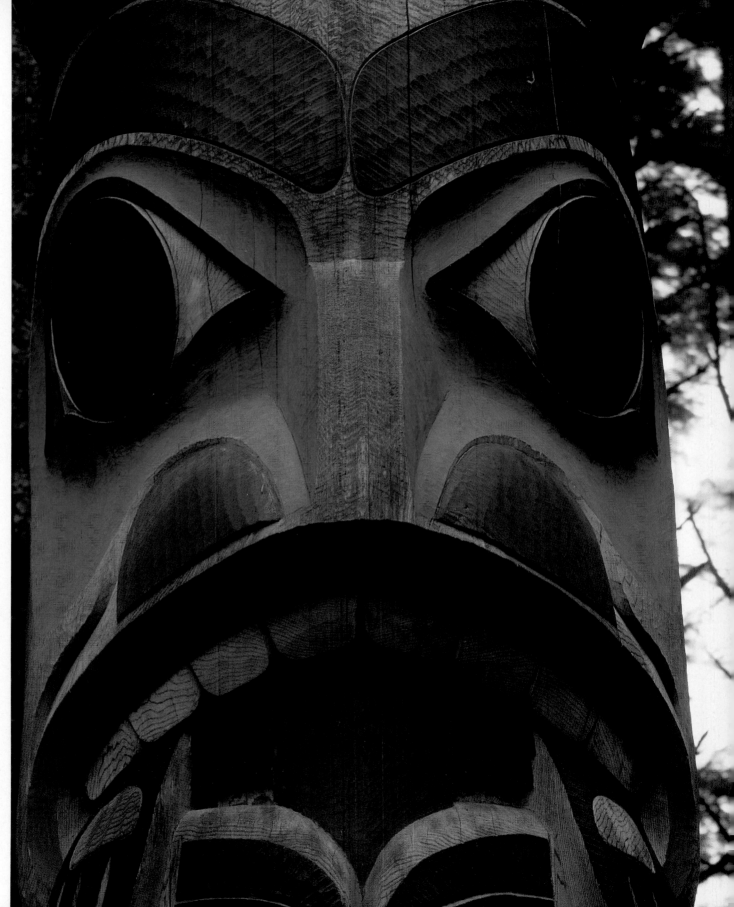

The fantastic figures on totem poles can usually be identified by their distinctive features. Beaver is recognized by his prominent teeth and cross-hatched tail, Bear by his protruding tongue and short, rounded ears. Eagle and Raven can be differentiated by the shape of their beaks, Raven's being long and straight and Eagle's shorter, heavier, and curved down. The mighty Thunderbird, crest of the most powerful chiefs, is always shown on totem poles with outstretched wings.

Totem detail, Sitka National Historic Park, Alaska

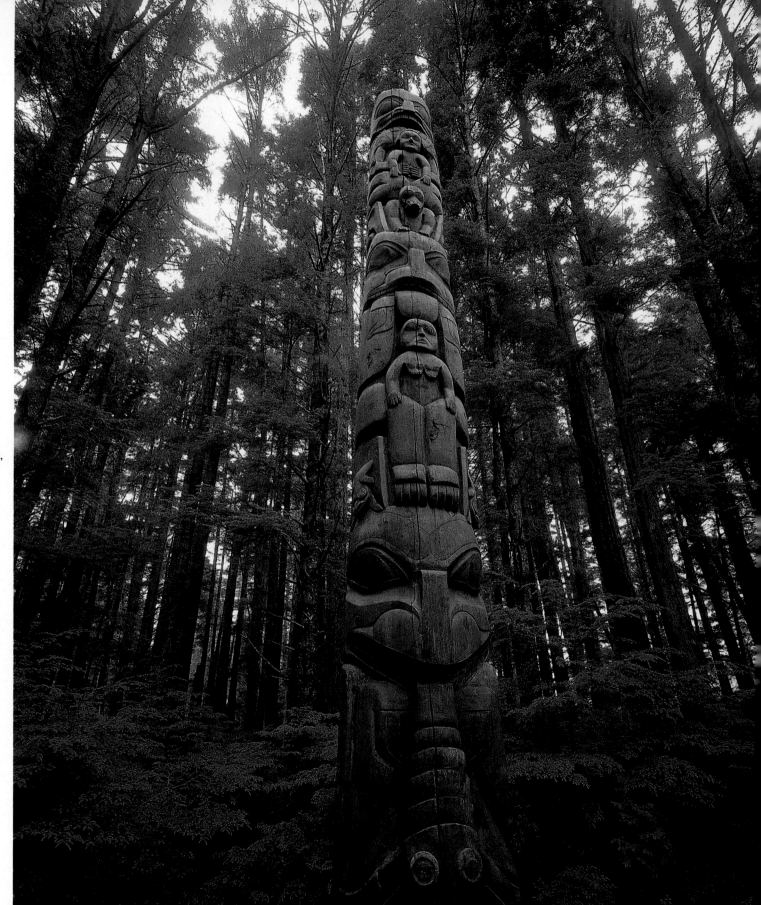

Lakichinei pole, Sitka
National Historic Park,
Alaska

Forest mosses, Tongass
National Forest, Alaska

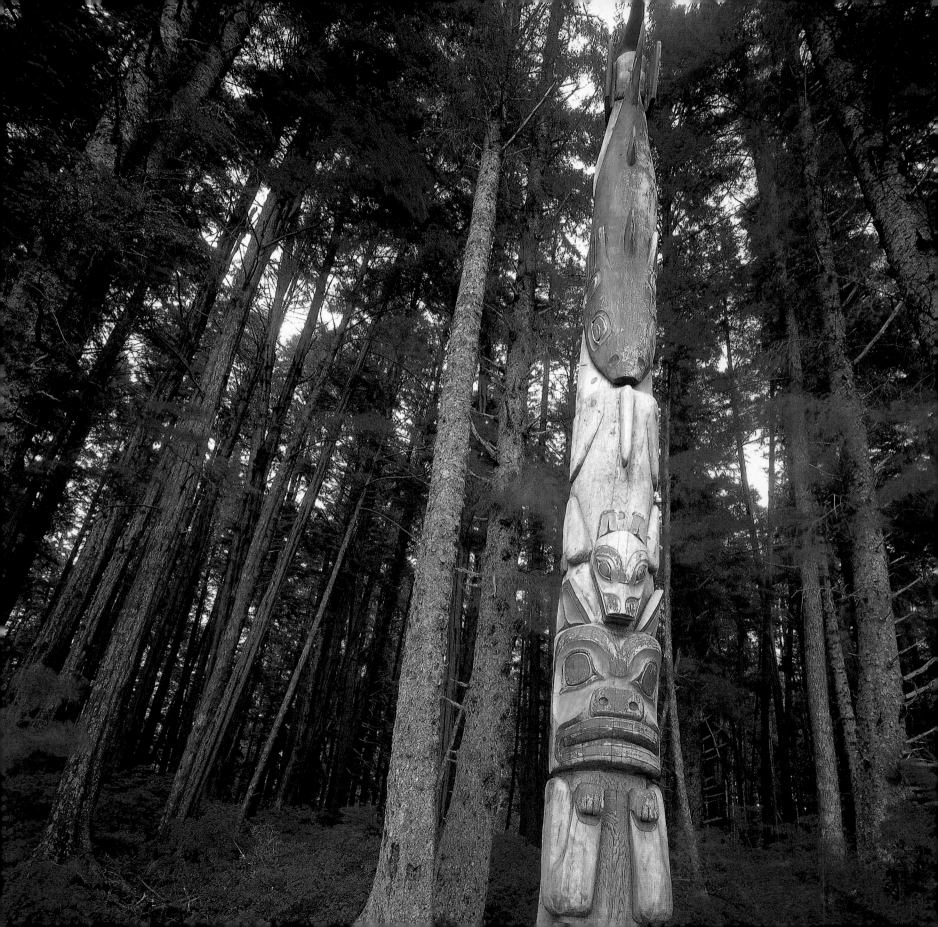

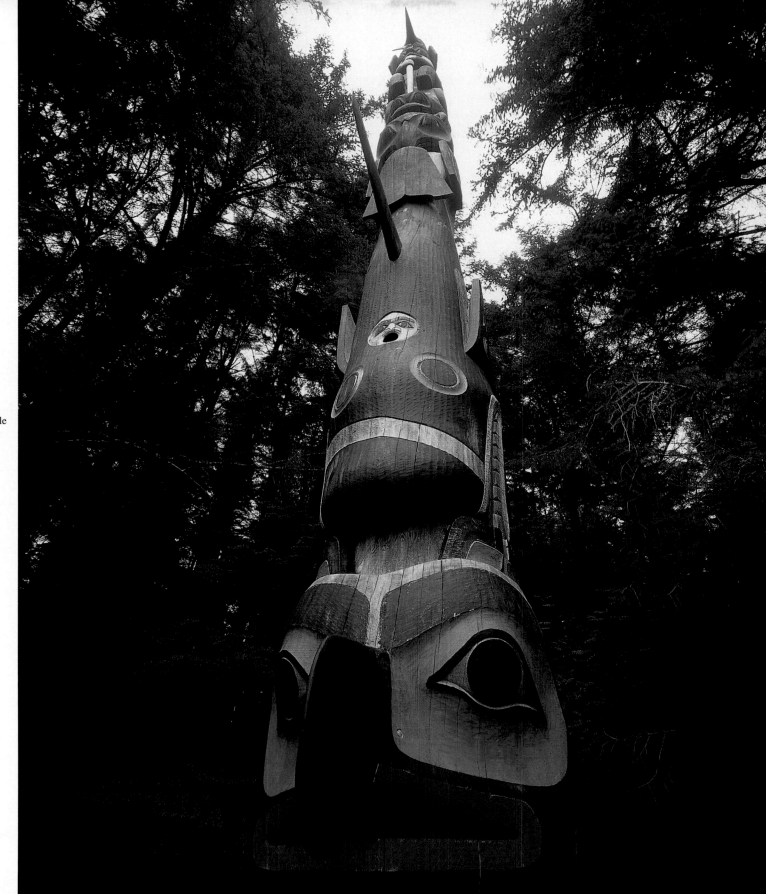

Gaanaxadi–Raven Crest pole
from Tlingit village of
Tuxekan, Sitka National
Historic Park, Alaska. *Left:*
Raven–Shark pole, Sitka
National Historic Park,
Alaska

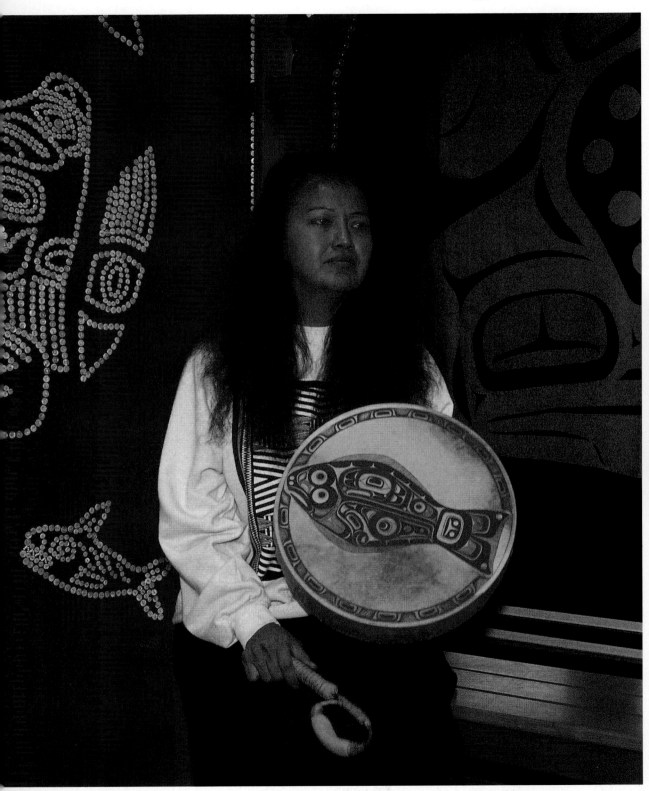

Jennifer Morales, skin and drum maker, Sitka National
Historic Park, Alaska

Tommy Joseph, Tlingit woodcarver, Sitka
National Historic Park, Alaska

Overleaf, left to right: Mosses on ancient tree stump,
Glacier Bay National Park, Alaska; horsetail, Glacier
Bay National Park, Alaska; variety of plant life grow-
ing on nurse log, Glacier Bay National Park, Alaska

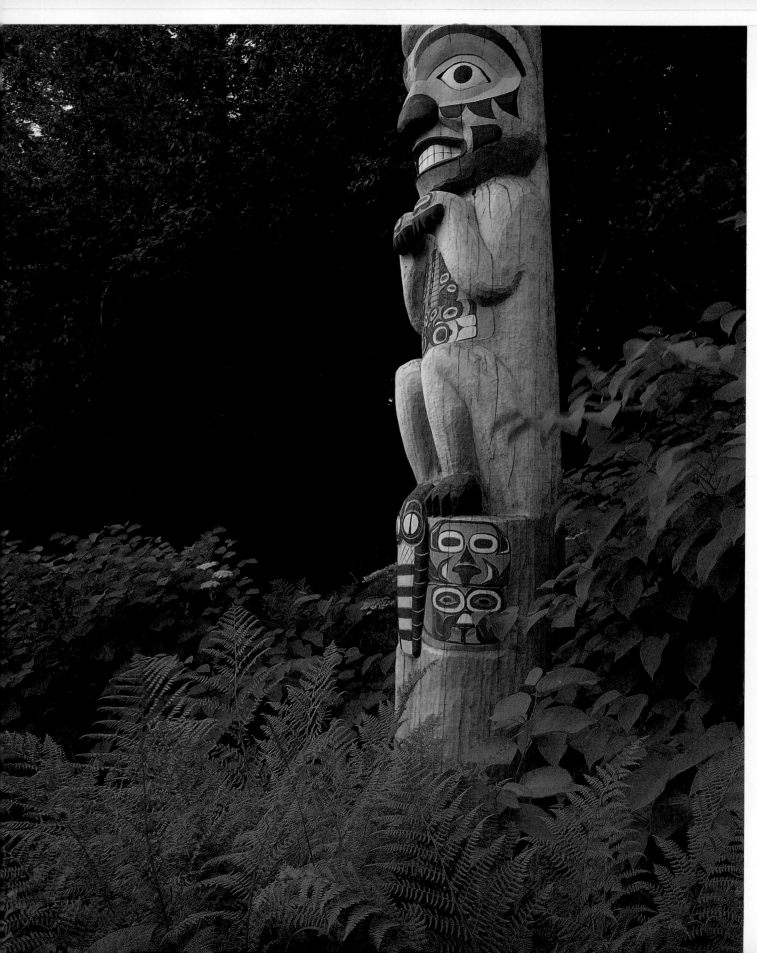

Yax-Te pole, Auke Bay, Alaska
Right: Ancient western red
cedar, the "Tree of Life,"
Alaska

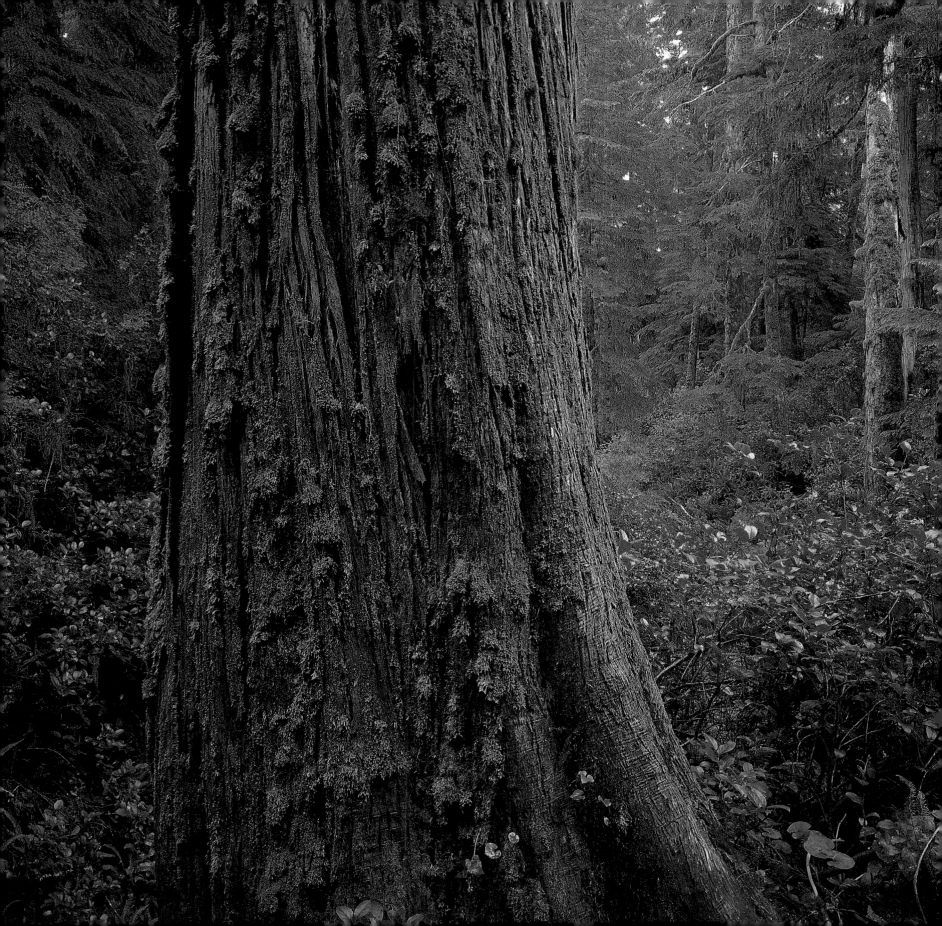

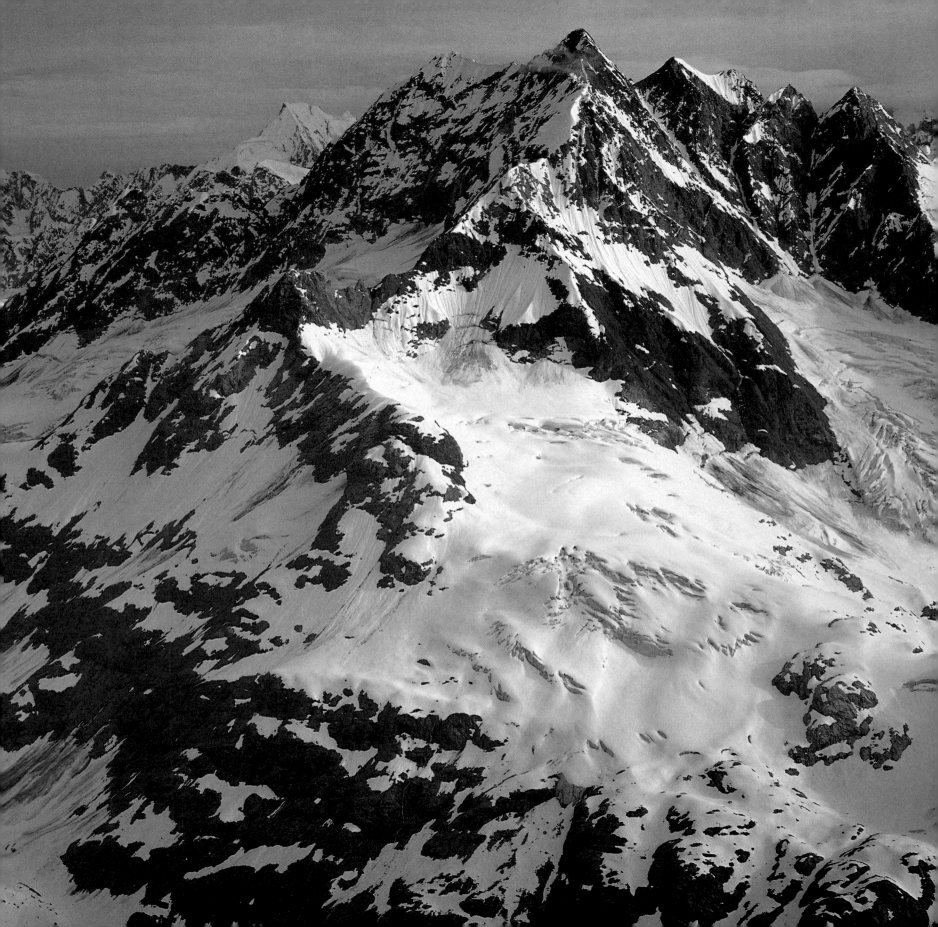

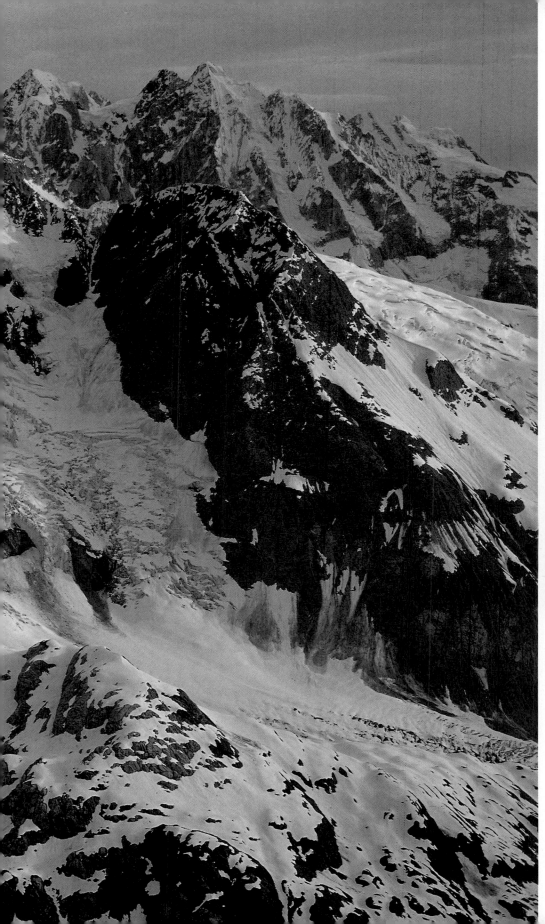

G
laciers,

remnants of the Pleistocene ice sheets

that covered much of North America, are composed

of snow, compacted under tremendous

pressure over time. Though they

still advance in the winter, in general the glaciers

are retreating as the earth

continues to warm.

Fairweather Range, Glacier Bay National Park, Alaska

Lupine at forest's edge, Glacier Bay National Park, Alaska

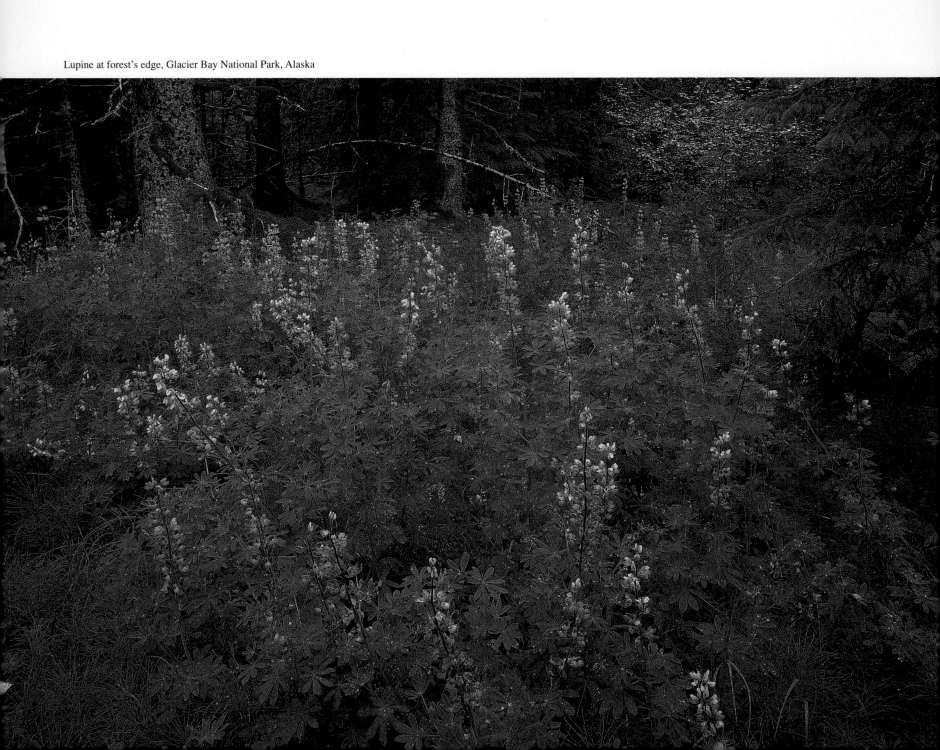

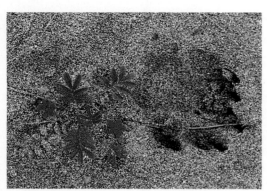

Wolf print, Glacier Bay National Park, Alaska

Yellow paintbrush on beach, Glacier Bay National Park, Alaska

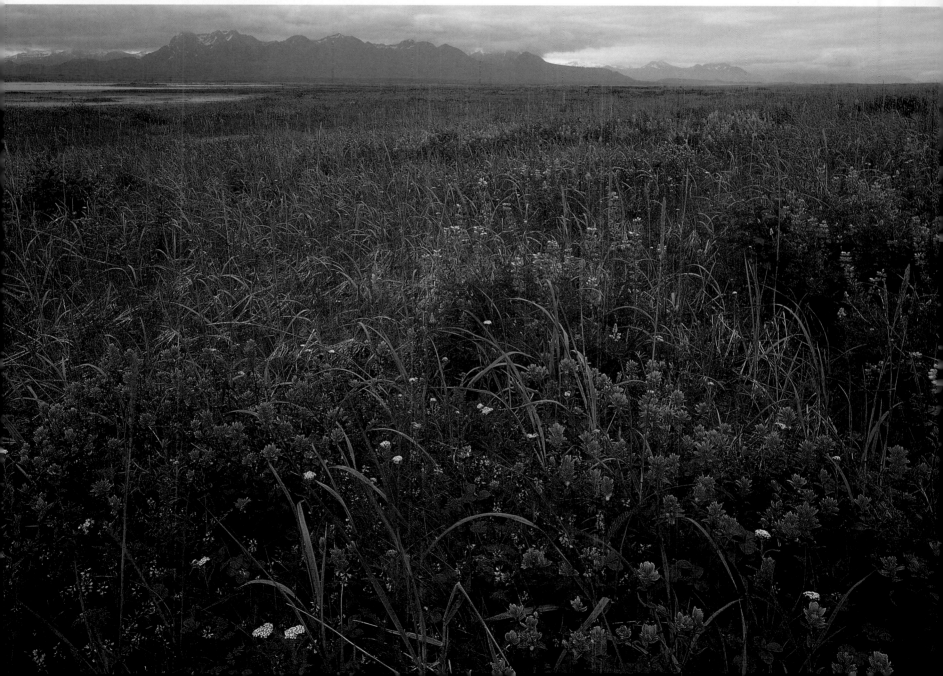

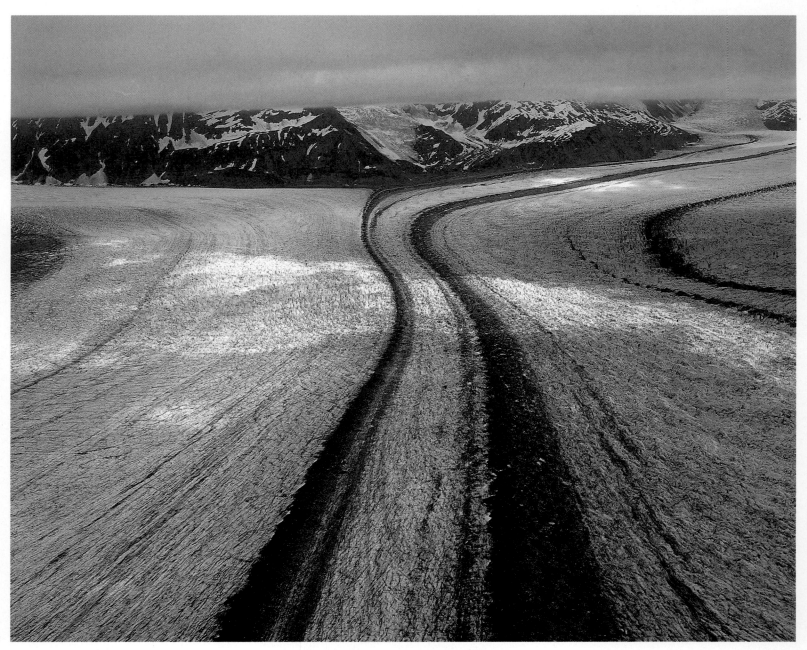

Grand Plateau Glacier, Glacier Bay National Park, Alaska

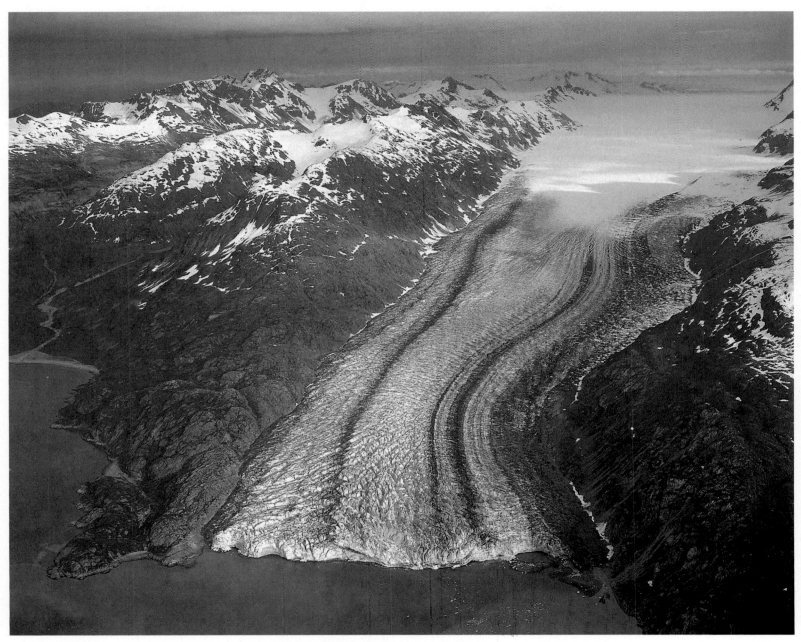

Lamplugh Glacier and Fairweather Range, Glacier Bay National Park, Alaska

BIBLIOGRAPHY

Brafford, C. J., and Laine Thom. *Dancing Colors: Paths of Native American Women.* San Francisco: Chronicle Books, 1992.

Brown, Dee. *Bury My Heart at Wounded Knee.* New York: Holt, Rinehart, and Winston, 1970.

Bruchac, Joseph. *Native American Stories.* Golden, CO: Fulcrum Publishing, 1991.

Caduto, Michael J., and Joseph Bruchac. *Keepers of Animals.* Golden, CO: Fulcrum Publishing, 1988.

————. *Keepers of the Earth.* Golden, CO: Fulcrum Publishing, 1988.

Clark, Ella. *Indian Legends of the Pacific Northwest.* Berkeley, CA: University of California Press, 1953.

Clark, Ella E. *Legends from the Northern Rockies.* Norman, OK, and London: University of Oklahoma Press, 1966.

Davis, Barbara A. *Edward S. Curtis: The Life and Times of a Shadow Catcher.* San Francisco: Chronicle Books, 1985.

Duffek, Karen. *Bill Reid: Beyond the Essential Form.* Vancouver: University of British Columbia Press, 1986.

Fitzgerald, Michael Orem. *Yellowtail: Crow Medicine Man and Sundance Chief.* Norman, OK, and London: University of Oklahoma Press, 1991.

Herger, Bob, and Rosemary Neering. *The Coast of British Columbia.* Anchorage: Alaska Northwest Books, 1990.

Holm, Bill. *Northwest Coast Indian Art: An Analysis of Form.* Seattle and London: University of Washington Press, 1965.

Houlihan, Collings, Nestor, and Batkin. *Harmony by Hand: Art of the Southwest Indians; Basketry, Weaving, Pottery.* San Francisco: Chronicle Books, 1987.

Hungry Wolf, Beverly. *The Ways of My Grandmothers.* New York: Quill, 1980.

James, H. L. *Rugs and Posts.* West Chester, PA: Schifter Publishing, 1988.

Jensen, Doreen, and Polly Sargent. *Robes of Power: Totem Poles on Cloth.* Vancouver: University of British Columbia Press, 1986.

Jonaitis, Aldona. *From the Land of the Totem Poles.* Seattle: University of Washington Press, 1991.

Josephy, Alvin M., Jr. *Now That the Buffalo's Gone.* Norman, OK, and London: University of Oklahoma Press, 1984.

Lobb, Allen. *Indian Baskets of the Pacific Northwest and Alaska.* Portland, OR: Graphic Arts Center, 1990.

Lowie, Robert H. *Indians of the Plains.* Lincoln, NE, and London: University of Nebraska Press, 1982.

MacNair, Peter, Alan L. Hoover, and Kevin Neary. *The Legacy: Tradition and Innovation in Northwest Coast Indian Art.* Vancouver and Toronto: Douglas & McIntyre, 1984.

Madsen, Brigham D. *The Shoshoni Frontier and the Bear River Massacre.* Salt Lake City: University of Utah Press, 1985.

Marriot, Alice. *The Ten Grandmothers.* Norman, OK, and London: University of Oklahoma Press, 1977.

Matsen, Bradford. *Northwest Coast: Essays and Images from the Columbia River to the Cook Inlet.* San Diego: Thunder Bay Press, 1991.

McQuiston, Don, and Debra McQuiston. *Dolls and Toys of Native America: A Journey through Childhood.* San Francisco: Chronicle Books, 1995.

————. *The Woven Spirit of the Southwest.* San Francisco: Chronicle Books, 1995.

McQuiston, Don, Jeremy Schmidt, and Thom Laine. *In the Spirit of Mother Earth: Nature in Native American Art.* San Francisco: Chronicle Books, 1994.

Medicine Crow, Joseph. *From the Heart of the Crow Country.* New York: Orion Books, 1992.

Niethammer, Carolyn. *Daughters of the Earth: The Lives and Keepers of American Indian Women.* London: Collier MacMillan Publishers, 1977.

Oberg, Kalervo. *The Social Economy of the Tlingit Indians.* Seattle and London: University of Washington Press, 1973.

O'Hara, Pat. *Olympic National Park: Where the Mountain Meets the Sea.* Del Mar, CA: Woodlands Press, 1984.

Portrait in Time: Photographs of the Makah by Samuel G. Morse, 1896–1903. Neah Bay, WA: Makah Cultural and Research Center, 1987.

Richardson, Fleming, Paula Lushy, and Judith Lynn. *Grand Endeavors of American Indian Photography.* Washington, DC: Smithsonian Institution Press.

Spencer, Robert, et al. *The Native Americans.* New York: Harper and Row, 1965.

Spradley, James, ed. *Guests Never Leave Hungry: The Autobiography of James Sewid, a Kwakiutl Indian.* Montreal and Kingston: McGill-Queen's University Press, 1969.

Stedman, Raymond W. *Shadows of the Indians.* Norman, OK, and London: University of Oklahoma Press, 1982.

Steltenhamp, Michael F. *Black Elk.* Norman, OK, and London: University of Oklahoma Press, 1993.

Stewart, Hilary. *Looking at Indian Art of the Northwest Coast.* Vancouver and Toronto: Douglas & McIntyre, 1979.

Taylor, Colin P., and William C. Sturtevant. *The Native Americans: The Indigenous People of North America.* New York: Salamander Books, 1991.

Thom, Laine. *Becoming Brave: The Path to Native American Manhood.* San Francisco: Chronicle Books, 1992.

Walter, Anna Lee. *The Spirit of Native America: Beauty and Mysticism in American Indian Art.* San Francisco: Chronicle Books, 1989.

Wherry, Joseph H. *Indian Masks and Myths of the West.* New York: Thomas Y. Crowell, 1974.

Acknowledgments

Produced by McQuiston & McQuiston; artifact photography by John Oldenkamp and coordinated by Grace Johnson; scenic photography by Tom Till; composition by ColorType; printed by South Seas International Press.

Special thanks should be given to the staff of San Diego Museum of Man: Grace Johnson, Curator, and Ken Hedges, Chief Curator. Without their assistance this book could not have been published. Additional thanks are owed to the staff at Makah Cultural and Research Center, Neah Bay, Washington, for their gracious assistance.